The Blue Bower
Rossetti in the 1860s

PAUL SPENCER-LONGHURST

The Barber Institute of Fine Arts
The University of Birmingham
27 October 2000 – 14 January 2001

The Sterling and Francine Clark Art Institute
Williamstown, Massachusetts
11 February – 6 May 2001

Scala Publishers in
association with
the Barber Institute
of Fine Arts

SCALA

First published in 2000 by Scala Publishers Ltd
143–149 Great Portland Street
London W1N 5FB

Distributed in the USA and Canada, outside the exhibition venues, by
Antique Collectors' Club
Market Street Industrial Park
Wappingers Falls, NY 12590

ISBN 1 85759 260 3

Edited by Helen Robertson
Designed by Linda Wade
Printed and bound by Sfera International Srl, Italy

All measurements are in centimetres followed by inches; height precedes width precedes
depth.

Contents page illustration: Dante Gabriel Rossetti, *La Ghirlandata* (detail)

VENUES OF THE EXHIBITION

27 October 2000 – 14 January 2001
The Barber Institute of Fine Arts
The University of Birmingham
Edgbaston, Birmingham B15 2TS

11 February – 6 May 2001
The Sterling and Francine Clark Art Institute
225 South Street
Williamstown, Massachusetts 01267

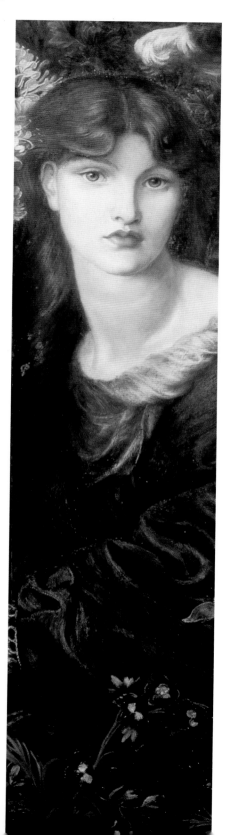

Contents

Preface

The City of Birmingham is renowned for its paintings and drawings by Pre-Raphaelite artists, one of the greatest of which is Dante Gabriel Rossetti's *The Blue Bower*, painted in 1865. Sole representative of the Pre-Raphaelites at the Barber Institute of Fine Arts, *The Blue Bower* is an undoubted masterpiece and marks the climax of Rossetti's achievement during the remarkable decade of the 1860s. How fitting, then, to celebrate the centenary of the University of Birmingham by exploring Rossetti's pioneering work during the ten years or so which fell to either side of its execution. We are particularly pleased that it has been possible to show the exhibition in the United States thanks to the eager co-operation of the Sterling and Francine Clark Art Institute, Williamstown, Massachusetts.

By 1860 Rossetti had largely abandoned his medievalizing watercolours of the 1850s and returned to painting in oils, a medium whose expressive qualities exactly matched the opulence of his new subject matter. This was female beauty, incorporated in a series of languorous 'stunners' such as Fanny Cornforth and Alexa Wilding. His depictions of them are not portraits in any conventional sense but poetic visions of beauty with abstract titles and underlying references to the exotic, the erotic and a fascination with death. They were painted in a decade that was crucial for British art as a whole, marking a reaction against the narrative painting of the previous fifty years. From the rise of Wilkie at the beginning of the century, British art had been dominated by genre painting based on the principle that 'every picture must tell a story'. By 1860, however, the religious, historical and social certainties of early Victorian society were being challenged and a new, more escapist art was needed. Over the following years there emerged the movement of 'art for art's sake', founded upon ideas brought from Europe and a burgeoning interest in Japan and the Orient. Rossetti played a major role in the creation of a more abstract concept of beauty, often linked with music. Together with Leighton, Whistler and Burne-Jones he set the stage for the later achievements of the Aesthetic Movement, European Symbolism and Art Nouveau.

Rossetti's paintings of the 1860s are pioneering yet deeply rooted in his knowledge of the Old Masters, especially the Venetians, and of Italian and British literature. They form an important turning point in his artistic career, yet retain links with his earlier pictures, elaborating the use of colour for symbolic purposes and focusing on the image of woman as symbol of the artist's creative 'soul'. This notion had made its original appearance in Rossetti's tale *Hand and Soul*, published in the first issue of *The Germ* in 1850. It was connected with the contemporary phenomenon of 'woman worship' but in

Rossetti's case assumed the character of a protest against the ideology of respectability that dominated middle-class life.

Since Rossetti's death numerous interpretations have been proposed for his 'female heads with floral attributes', as they were termed by his brother, William Michael. They have been characterized *inter alia* as sacred pictures of a new religion, milestones of stylistic innovation, Marxist documents demonstrating market forces, male responses to Victorian feminism and objects of psychoanalytical investigation. The aim of the present exhibition is to focus on Rossetti's development in the context of one crucial decade, thereby defining his artistic originality and his contribution to wider cultural issues present and future.

The realization of this remarkable exhibition is attributable to Paul Spencer-Longhurst, Senior Curator at the Barber Institute of Fine Arts, whose imagination and expertise have guided it through all stages of the planning, from the splendid choice of loans to the thought-provoking catalogue. We are deeply grateful to him, and to those who have assisted him in devising the exhibition, for the pleasure and insight it is certain to afford to audiences on both sides of the Atlantic.

Richard Verdi,
Director,
The Barber Institute of Fine Arts,
The University of Birmingham

Michael Conforti,
Director,
The Sterling and Francine Clark Art
Institute,
Williamstown, Massachusetts

Acknowledgements

Among the many contributors to the preparation of this exhibition and catalogue I would like to acknowledge with particular appreciation the co-operation, assistance and enthusiasm of John Anderson, Dr Timothy Barringer, Margaret Birley, Dr Nicola Bown, Michael Conforti, Alexis Goodin, Yvonne Locke, Rupert Maas, Patrick McCaughey, John McDill, Christopher Newall, Dr Nicolas Penny, Rosemary Poynton, Elizabeth Prettejohn, Richard Rand, Tessa Sidey, Virginia Surtees, The Friends of the Barber Institute, Julian Treuherz, Robert Upstone, Professor Richard Verdi, Dr Malcolm Warner, Ming Wilson, Sophie Wilson, Glennys Wild and Terry Wood.

The preliminary research was made possible by a period of study leave granted by the University of Birmingham. Further research and much of the writing of the catalogue were done at the Yale Center for British Art, New Haven, during my Visiting Fellowship there. To both of these institutions I would like to express my thanks. I am deeply grateful for the generous forbearance of my colleagues at the Barber Institute at my prolonged absences over the past year. None of it would have happened without the constant support of Sue Spencer-Longhurst and Rose and Flora.

'The Blue Bower': Rossetti in the 1860s enjoys the valued support of Shakespeares Solicitors, Birmingham, for which we are most grateful.

Paul Spencer-Longhurst

Abbreviations

The following abbreviations are used throughout the catalogue:

Academy Notes	*Notes on the Royal Academy Exhibition, 1868.* Part I, by William Michael Rossetti; Part II, by Algernon C. Swinburne, London, 1868.
Doughty and Wahl	Oswald Doughty and John Robert Wahl (eds), *Letters of Dante Gabriel Rossetti*, 4 volumes, Oxford, 1965–7.
Marillier	H. C. Marillier, *Dante Gabriel Rossetti: An illustrated Memorial of his Art and Life*, London, 1899.
Surtees	Virginia Surtees, *The Paintings and Drawings of Dante Gabriel Rossetti (1828–1882): A Catalogue Raisonné*, 2 volumes, Oxford, 1971.

List of Lenders

The numbers below refer to the catalogue entries

Aargauer Kunsthaus, Aarau	25
The Barber Institute of Fine Arts, The University of Birmingham	8, 19
Birmingham Museums and Art Gallery	12, 20, 26, 34, 36, 37, 38, 39, 41
Museum of Fine Arts, Boston	1
Russell-Cotes Art Gallery and Museum, Bournemouth	5
The Syndics of the Fitzwilliam Museum, Cambridge	3, 30, 32
The Faringdon Collection Trust	23
Hamburger Kunsthalle	4
Guildhall Art Gallery, Corporation of London	11
Derek Johns Ltd, London	14
National Gallery, London	13
National Portrait Gallery, London	24, 40
Tate Britain, London	9, 16, 28, 29, 31, 35
Victoria and Albert Museum, London	44
William Morris Gallery, London	42
Yale Center for British Art, New Haven	21
The Visitors of the Ashmolean Museum, Oxford	27
Philadelphia Museum of Art	15, 18
Pre-Raphaelite Inc., by courtesy of Julian Hartnoll	22
National Gallery of Scotland	7
Nationalmuseum, Stockholm	17
Private Collection, UK	33
National Museums and Galleries of Wales	2
The Sterling and Francine Clark Art Institute, Williamstown, Massachusetts	43
Delaware Art Museum, Wilmington	6, 10

'The Blue Bower'

On 18 April 1865 Rossetti wrote to his close friend and fellow artist Ford Madox Brown: 'I've begun an oil-picture all blue, for Gambart, to be called *The Blue Bower*. Come and see it in a week's time.'[1] The work in question was the latest in a series of idealized images of sensuous women graced with poetic titles, which he had started six years earlier with *Bocca Baciata* (cat. 1). These works, which are not portraits in any conventional sense, have certain features in common. They are visionary, saturated with colour and set in confined spaces, allowing the artist to concentrate on ever-increasing opulence, sophistication of hue, and beguiling decoration. *The Blue Bower* is the climax of the series. It was eulogized by H. C. Marillier, Rossetti's most perceptive nineteenth-century biographer, as:

> . . . representing in a setting of the most gorgeous blue and green harmonies a beautiful woman playing upon a dulcimer. Blue tiles are at her back, blue cornflowers by her side; blue turquoises in her hair and deep blue eyes are other notes in the scheme such as Rossetti loved to plan. And the lady herself is clad in a fur-lined robe of green, such green as that which the sea knows, and of which she shares the secret with a chosen few of the world's great colourists.[2]

The Blue Bower also marks the crowning appearance of the model of *Bocca Baciata*, Fanny Cornforth, whose sensuality, though certainly founded in physical fact, appealed to Rossetti as a reminiscence of the Renaissance courtesans painted by Titian, Palma Vecchio and Veronese (fig. 1).

 Cornforth (1835–1906), whose real name was Sarah Cox, had fascinated Rossetti since he first encountered her in the late 1850s. Over the years this Junoesque Cockney beauty graduated from model to mistress and, after the death of Rossetti's wife in 1862, became his housekeeper at Cheyne Walk. The date of their first meeting is uncertain. According to her account it took place during the celebrations to welcome Florence Nightingale in August 1856.[3] The painter and poet William Bell Scott set the meeting unforgettably in the Strand: 'She was crunching nuts with her teeth, and throwing the shells about; seeing Rossetti staring at her, she threw some at

Fig. 1 William Downey, *Fanny Cornforth*, photograph, 1863
Rupert Maas, by courtesy of the National Portrait Gallery, London

Opposite: Fig. 2
Dante Gabriel Rossetti, *Found*, begun 1854, left unfinished
Delaware Art Museum, Wilmington

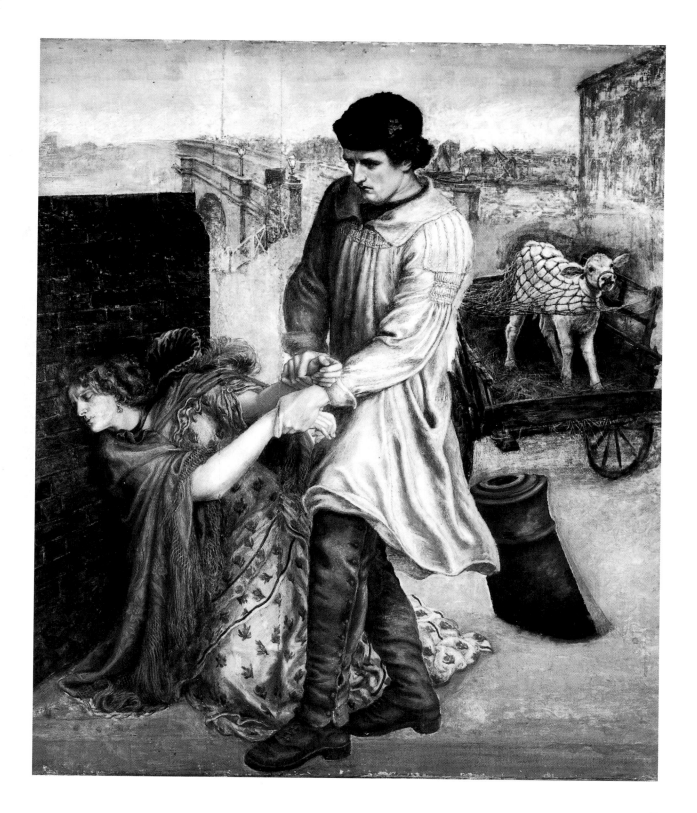

him. Delighted with this brilliant naïveté, he forthwith accosted her and carried her off to sit for him for her portrait.'[4] Contact was certainly established before January 1858, when Ford Madox Brown recorded seeing her modelling for Rossetti and Burne-Jones.[5] Buxom, healthy and possessing an earthy sense of humour, Fanny Cornforth could hardly have been a greater contrast to the delicate and sickly Elizabeth Siddal, whom Rossetti married after much delay in 1860 (cat. 27). Fanny's Cockney manner prevented her acceptance by most of Rossetti's friends, but her long neck, auburn hair and sensuous lips appear in numerous paintings, including *Found* (fig. 2), *Fair Rosamund* (cat. 2) and *Fazio's Mistress* (fig. 3). The nature of her attraction was neatly summarized by Rossetti's friend George Price Boyce, a connoisseur of young women's charms, who noted that she possessed an 'interesting face and jolly hair and engaging disposition'.[6] For Rossetti her handsome, coarse-grained voluptuousness, was irresistible and led him to make numerous drawings of her over the

years, surprisingly few of which are linked to *The Blue Bower*. One is a pencil study for the angle of her head and arrangement of the hair (cat. 36). Another reveals something of the genesis of the composition, showing more of her face, differently arranged hair, and an upright stringed instrument against which her head is resting (fig. 4). On the reverse are two dates, April 1865 and 22 May 1865, inscribed by Boyce, who acquired the drawing that year.

Fig. 3 Dante Gabriel Rossetti, *Fazio's Mistress (Aurelia)*, 1863 Tate Britain, London

No drawings survive which indicate the development of the picture, or the incorporation of exotic jewellery and flowers. Of all the richly painted details, perhaps the most extraordinary are the blue and white tiles of the background. Hexagonal in shape, they are decorated with circular designs incorporating prunus blossoms and reflecting the fascination of Rossetti and his circle with Oriental blue-and-white porcelain. He had a fondness for geometrical backgrounds, as may be seen seen in the title page of his book *The Early Italian Poets*, published in 1861, and in designs for stained glass made the same year. These were executed for the newly founded firm of Morris, Marshall, Faulkner and Company, which specialized in stained glass and other applied arts and drew Rossetti increasingly towards decorative considerations at this time. He may also have been reacting to the publication

in 1856 of Owen Jones's seminal book, *The Grammar of Ornament*. Blue-patterned tiles first appear in his watercolour *The Blue Closet*, painted that year (cat. 28). But the tiles in *The Blue Bower* correspond to no Oriental prototypes. Their round designs within the hexagons suggest rather the Chinese 'hawthorn' ginger jars admired by Rossetti and Whistler and supplied by the dealer Murray Marks. One was reproduced on his trade card, designed by Rossetti, and another appears prominently in *Monna Rosa, Portrait of Mrs Leyland* (unlocated), painted in 1867. Their shape, colour and pattern were integrated with hexagons, possibly suggested by the six-sided plates produced in Japan, to create a tiled wall of deepest blue. Perhaps coincidentally, the effect produces star-like patterns, one of which silhouettes the sitter's head to the left, acting as a kind of halo.

To left and right passion flowers and clinging wild convolvulus blossoms make a luxuriant contrast with the hard surfaces of the tiles and symbolize Fanny's nature as passionate and clinging. Their opulence is balanced by the modest sprig of light-blue cornflowers in the foreground, playing on her surname. These ornaments of nature are complemented by the prominent jewellery that adorns her hair, ear and neck, its designs suggesting remote and exotic lands. The heart brooch (cat. 44), which is significantly sited at the exact centre of the composition, belonged to Rossetti and was believed to be of Indian origin,[7] while the gold buttons of her cloak seem to be Chinese. Her extravagant hair-clip is a Chinese 'kingfisher' type, although these are usually attached to pins.

The instrument that she fingers, often referred to as a dulcimer, is in fact a Japanese *koto,* a kind of zither. It has movable bridges and normally thirteen silk strings, although Rossetti shows fourteen. *Kotos* traditionally had links with young women; they were usually played by girls, and in Japanese romances lost maidens were often found by the sound of their *koto* playing. The instrument is played by plucking, either with the fingertips or, more usually, with an ivory plectrum. Fanny, however, is unlikely to be making a sound, since the technique involves using the left hand to alter the pitch slightly by pressing on the string behind the bridge (see fig. 5). By contrast, her hands are arranged so as to display their elegance, 'performing with rosy fingers in a dainty action'.[8] The *koto* is usually larger than shown here, and was normally played on the floor, across the knees or on a low table. Its present position is unrealistically high but serves to

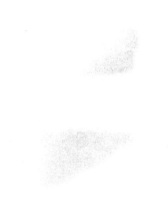

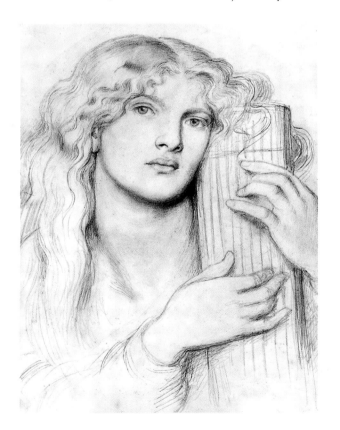

Fig. 4 Dante Gabriel Rossetti, *Study of Fanny Cornforth for 'The Blue Bower'*, pencil, 1865 Private Collection, USA

provide a parapet behind which the sitter is confined – a common device of Rossetti's, ultimately deriving from Renaissance prototypes. However, short *kotos* or *ayame-koto* were made in Japan until the middle of the nineteenth century. They were played by court nobles on ships or carts for entertainment on pleasure trips.[9] Whatever his adaptations, Rossetti's use of the *koto* confirms his interest in the fashionable *japonaiserie* that had taken Paris by storm around 1860 and was much in evidence in London at the International Exhibition of 1862. On his trip to Paris in 1864 Rossetti recorded a visit to Madame de Soye's famous shop in the rue de Rivoli, where he bought four Japanese books, lamenting that the costumes had been snapped up by James Tissot, who was painting three Japanese pictures.[10] But undoubtedly part of his interest in the *koto* was his love of archaic and unfamiliar objects. He made a habit of collecting old and mostly unplayable instruments, which he prized for their quaintness rather than for any musical quality they might possess. He himself was unmusical – indeed, he disliked music. His assistant, Henry Treffry Dunn, declared that he never heard a single note of music issue from any of the 'mandolins, lutes, dulcimers, barbarous-looking things of Chinese fashion' in his employer's house.[11] But such instruments were too tempting when seen in the curiosity shops of Leicester Square or Hammersmith, and Rossetti later admitted that in the mid-1860s '[I] had a mania for buying bric-a-brac and used to stick it in my pictures'.[12]

Fig. 5 A full-size *koto* played by Rié Yanagisawa

In this rarefied setting the massive figure of Fanny provides a fleshly focus, the smooth, silvery tones of her ample body revealed alluringly behind the furry lining of her parted robe. She is crowned with an abundance of rich, auburn hair, which likewise parts to reveal her blue eyes, deep red lips and jewelled ear. It tumbles voluptuously down her back, with a stray wisp curling forward enticingly round her neck. In this and other paintings by Rossetti, hair is given great significance as a metaphor for female sexuality. One obvious literary precedent for this connection was Alexander Pope's *Rape of the Lock*, first published in 1712. For Rossetti and his contemporaries the colour and profusion of a woman's hair were especially important. Auburn or 'red' hair was generally held to denote a passionate, wilful or evil temperament. Thus, in Wilkie Collins's *Armadale* of 1866, the bigamist, husband-poisoner and laudanum-addict Lydia Gwilt is described to her detriment as flame-haired: 'This woman's hair, superbly luxuriant in its growth, was of the one unpardonably remarkable shade of colour which the prejudice of the Northern nations never entirely forgives – it was *red*.'[13] Undressed hair on adults was taken to indicate sexual readiness or looseness of morals. Rossetti's Pre-Raphaelite associate Millais painted an unforgettable image of adolescent yearning in 1851, *The Bridesmaid* (fig. 6). In this the girl's streaming auburn tresses, half-closed eyes unfocused in reverie and lips invitingly parted all signify the power of her passion, although the orange blossom at her breast proclaims her chaste for the present. Rossetti's fascination with flowing female tresses permeated his watercolours of the 1850s and assumed a specific connection with loose morality in 1858 with his drawing of the repentant harlot, *Mary Magdalene at the Door of Simon the Pharisee* (cat. 30). In 1862 he designed a frontispiece for his sister Christina's volume of poetry, *Goblin Market and other Poems*, in which payment for the goblin merchants' magic fruit is made with a lock of golden hair, the colour in this case signifying purity. Later instances in his work of uncontrolled hair as a metaphor for women's evil, madness or misfortune include images of Lady Macbeth, Desdemona and Cassandra. Across the Channel, Courbet gave the same significance to the loosened red hair of Joanna Hiffernan in *Jo, The Beautiful Irish Girl* (cat. 17) and over the following decades the relationship of flowing tresses to aggressive female sexuality became a commonplace among Symbolist painters, reaching a climax with Edvard Munch's *Madonna* (cat. 43).

Rossetti chose a poetic and enigmatic title for his painting. 'Bower' was a word used by Coleridge, Keats, Tennyson and other Romantic poets to denote a sequestered setting for love – either a lady's private apartment in a medieval castle, or a sheltered place in a garden made from boughs. Its erotic and self-indulgent associations are made clear in Tennyson's *Oenone*:

Naked they came to that smooth-swarded bower,
And at their feet the crocus brake like fire,
Violet, amaracus, and asphodel,
Lotos and lilies.[14]

Shakespeare had established the connection of bowers with music in
Henry IV, Part I:

. . . sweet as ditties highly penn'd,
Sung by a fair queen in a summer's bower,
With ravishing division, to her lute.[15]

Rossetti used the word in his poems and in the titles of watercolours, such
as *The Bower Garden* of 1859 (Private Collection), in which Fanny
Cornforth featured. Verse 1 of his *Song of the Bower* describes the ethos of
such a place:

Say, is it day, is it dusk in thy bower,
Thou whom I long for, who longest for me?
Oh! Be it light, be it night, 'tis Love's hour,
Love's that is fettered as Love's that is free.
Free Love has leaped to that innermost chamber,
Oh! the last time and the hundred before:
Fettered Love, motionless, can but remember,
Yet something that sighs from him passes the door.

Verse 3 is particularly close to *The Blue Bower*:

What were my prize, could I enter thy bower
This day, tomorrow, at eve or at morn?
Large lovely arms and a neck like a tower,
Bosom then heaving that now lies forlorn.
Kindled with love-breath, (the sun's kiss is colder!)
Thy sweetness all near me, so distant today;
My hand round thy neck and thy hand on my shoulder,
My mouth in thy mouth as the world melts away.

Rossetti's title also emphasizes the importance of colour and the
painting's harmonies of blues and greens – most obvious in the daring
contrast of blue tiles with green robe, but also echoed in the cornflowers,
eyes and hair decoration. As early as 1854 he had declared his belief in

colour as an indispensable ingredient of the best art and, at about the time of painting *The Blue Bower*, he listed his colour preferences as: '(1) Pure light warm green, (2) deep gold colour, (3) certain tints of grey, (4) shadowy or steel blue, (5) brown, with crimson tinge, (6) scarlet. Other colours (comparatively) only lovable according to the relations in which they are placed'.[16] His use of colour by degrees in a kind of scale links his paintings at this time with Whistler's colour experiments such as *Symphony in White, No. III* (cat. 19). But Rossetti refused to acknowledge Whistler as the source of his experiments in colour, claiming conversely that his own *Ecce Ancilla Domini* (Tate Britain) was the 'ancestor of all the white pictures which have since become so numerous'.[17]

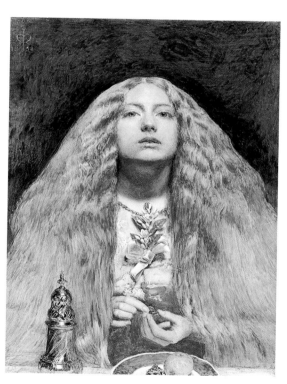

The sheer exuberance of the colours and the hedonistic qualities of the girl's flesh mark *The Blue Bower* as one of Rossetti's most 'Venetian' pictures. Unlike the other members of the Pre-Raphaelite Brotherhood, he had always revered the painters of the Venetian Cinquecento, insisting on the inclusion of Giorgione, Titian and Veronese in the 'List of Immortals' that he drew up with Holman Hunt in 1848.[18] On his first visit to Paris, in 1849, he commented enthusiastically on the Giorgiones and Titians in the Louvre, and on his return to oil-painting in 1859 it was naturally to the Venetian masters that he looked for inspiration.[19] Their influence is paramount, not only in *The Blue Bower* but also in the other fanciful images of women that he painted in the 1860s. In celebrating female beauty and luxuriating in rich fabrics, he chose to base himself on such antecedents as Palma Vecchio's '*Sybil*' (cat. 14), a version of which he knew in Hampton Court. Others which he had not seen, such as Titian's *Flora* in the Uffizi or *Sacred and Profane Love* in the Villa Borghese, would have been familiar through his collection of autotype facsimiles after Titian. His borrowings from the opulent Venetian palette were soon recognized and acclaimed. Marillier praised *The Blue Bower* as 'sensuous yet not sensual, sensuous with all the exquisite sensuousness of a creation by Titian or Giorgione'.[20] But to modern eyes Rossetti has taken one crucial step further, by promoting colour as the primary subject of his painting, giving it precedence over narrative and even meaning. In this way *The Blue Bower* stands apart from Burne-Jones's early narrative watercolours, such as *Cinderella* (1863, Museum of Fine Arts, Boston), where Cinderella's mottled green gown is set off by rows of blue plates behind her head. By suppressing the anecdotal, Rossetti was able to give two-dimensional emphasis to his painted surfaces. These pictorial

advances in the direction of abstraction surely establish him as one of the founders of modern art.

The Blue Bower was finished by 8 October 1865.[21] Rossetti was paid 200 guineas for it by the 'prince of dealers', Ernest Gambart, who sold it on to his colleague Agnew a year later for 500 guineas. Soon afterwards it was purchased by Samuel Mendel, a textile merchant of Manchester, for a sum rumoured to be 1,500 guineas. Gambart strenuously denied this and accused Rossetti of having invented the figure. Nevertheless, their relations remained cordial and Rossetti believed that he had done well from the picture. He was now at the height of his prosperity, successfully painting in oils and making an income of about £2,000 per year.

Critical responses to The Blue Bower were mixed, but its abstract qualities were noted by F. G. Stephens, who wrote:

> There is nothing to suggest subject, time or place. Where we thus leave off, the intellectual and purely artistic splendour of the picture begins to develop itself. The music of the dulcimer passes out of the spectator's cognizance when the chromatic harmony takes its place in appealing to the eye.[22]

Over 30 years later, William Michael Rossetti characterized the work as

> . . . one of my brother's most vigorous and brilliant pieces of painting, with much sumptuous accessory. It is, however, less ideal and more sensuous in feature and treatment than almost any other of his female figures: hence, while it attracts some eyes, it is in comparative disfavour with others.[23]

Fortunately, in a more liberal age, his moral misgivings need no longer cloud the admiration which this masterpiece so richly deserves.

NOTES

1. Doughty and Wahl, II, p. 552.
2. Marillier, p. 137.
3. P. F. Baum (ed.), *Dante Gabriel Rossetti's Letters to Fanny Cornforth*, Baltimore, 1940, p. 12.
4. W. Minto (ed.), *Autobiographical Notes of the Life of William Bell Scott*, I, London, 1892, pp. 316–7.
5. F. M. Hueffer, *Ford Madox Brown: A Record of his Life and Work*, London, 1896, p. 154.
6. V. Surtees (ed.), *The Diaries of George Price Boyce*, Norwich, 1980, p. 25, 15 December 1858.
7. S. Bury, 'Rossetti and his Jewellery', *Burlington Magazine*, CXVIII, February 1976, pp. 98, 101.
8. F. G. Stephens, *The Athenaeum*, no. 1982, 21 October 1865, p. 545.
9. Information kindly supplied by Professor Sumi Gunji and Margaret Birley.
10. Doughty and Wahl, II, pp. 526–7.
11. H. T. Dunn, *Recollections of Dante Gabriel Rossetti and his Circle*, ed. R. Mander, Westerham, 1984, p. 18.
12. W. M. Rossetti, *Dante Gabriel Rossetti as Designer and Writer*, London, 1889, p. 69.
13. W. Collins, *Armadale*, Book the Third, chapter x, Penguin Classics, 1995, p. 277. See further R. Altick, *The Presence of the Present*, Columbus, Ohio, 1991, p. 323.
14. Tennyson, *Oenone* (1833), lines 93–6.
15. *Henry IV, Part I*, III, i, 208–10.
16. Marillier, p. 137, n. 1.
17. Unpublished letter to F. G. Stephens, 25 August 1874, Bodleian Library, Oxford, quoted in Surtees, p. 14.
18. D. S. Macleod, 'Dante Gabriel Rossetti and Titian', *Apollo*, CXXI, January 1985, p. 36.
19. Doughty and Wahl, I, pp. 65–6, 71.
20. Marillier, p. 138.
21. Doughty and Wahl, II, p. 575.
22. *The Athenaeum*, loc. cit., pp. 545–6.
23. W. M. Rossetti, *Dante Gabriel Rossetti as Designer and Writer*, London, 1889, p. 54.

Rossetti in the 1860s

Dante Gabriel Rossetti is best known for his early Pre-Raphaelite paintings, his poems and a prodigious number of watercolours and drawings. The later part of his career has come to seem like a prolonged coda of unexpected and little-known developments, involving a return to oil-painting and the pioneering of a new kind of art devoted to idealizing beautiful women, which is so different from his first Pre-Raphaelite style as to be almost alien to it. His controversial and unsuccessful exhibition of *The Girlhood of Mary Virgin* and *Ecce Ancilla Domini* in 1849 and 1850 respectively convinced him never again to submit to the vagaries of public exhibition, and directly brought about his withdrawal during the succeeding decade into a private world of watercolour where subjects from Dante, Malory and other medieval sources predominated. These delicately wrought, fanciful and nervously intense works were a projection of Rossetti's personal obsessions and identification with the medieval world as he perceived it.

In the eyes of his contemporaries, Rossetti's early career was unproductive, for after 1850 not a single work appeared in a public exhibition for almost a decade. Yet the only occasion on which Rossetti tried to break this mould was with his ill-fated modern moral subject, *Found*, which he began during the early months of 1854 (fig. 2). The work was never completed and he had to watch his colleague, Holman Hunt, gaining attention at the Royal Academy with *The Awakening Conscience* (fig. 7), where a woman of easy virtue is suddenly seized by remorse. Having returned to Arthurian subjects, Rossetti found his position improved by the patronage of John Ruskin, who bought watercolours himself and introduced him to a range of patrons, including the architect J. P. Seddon. Seddon was restoring Llandaff Cathedral and commissioned as an altarpiece *The Seed of David*, Rossetti's only large oil-painting of the 1850s. Ruskin also encouraged Rossetti's Arthurian subjects, which became paramount in his work during the mid-1850s and culminated in the decoration of the Oxford Union Society's Debating Hall in 1857. In the wake of this technically disastrous project Rossetti seems to have turned a corner, beginning a new career devoted to the cult of feminine beauty.

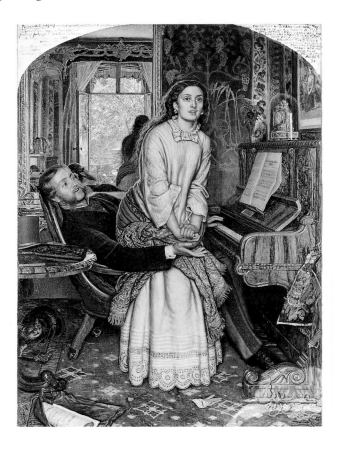

Fig. 7 William Holman Hunt,
The Awakening Conscience, 1853–4
Tate Britain, London

Opposite: Fig. 8
Dante Gabriel Rossetti,
The Beloved ('The Bride'), 1865–6
Tate Britain, London

changing love was a condition of his existence and he was addicted to 'loves of the most material kind both before and after his marriage, with women, generally models, without other soul than beauty'.[2] In the mid-1850s he began to draw women other than Elizabeth Siddal. Highly finished head-and-shoulder portraits were made of Annie Miller, Jane Burden, Ruth Herbert and Fanny Cornforth in celebration of their beauty. In each case the same features were emphasized – length of neck, firmly modelled profile, cupid's-bow mouth, hooded eyes and richly waving hair. These were the crucial hallmarks for Rossetti, who believed that the eyes represented the spiritual part of the sitter, whereas the mouth indicated the sensual.

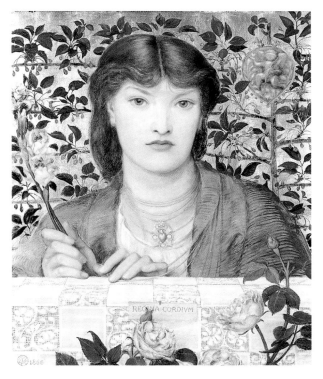

Fig. 11 Dante Gabriel Rossetti, *Regina Cordium*, 1866 Glasgow Museums: Art Gallery & Museum, Kelvingrove

Annie Miller sat occasionally from about 1854, although Holman Hunt regarded her as his exclusive model, having discovered her at the age of 15 in a Chelsea slum. He attempted to educate her and wanted to marry her, but broke off their engagement in 1859 on account of Rossetti's association with her during his absence in the Holy Land. Miller continued to model for Rossetti until 1863, appearing in that year as *Helen of Troy* (cat. 4). Her lower-class origins struck a chord in him and were similar to those of another model, Ellen Smith, who often sat to him and his susceptible friend George Price Boyce in the 1860s. A laundry maid, said to have been of 'uncertain virtue', Smith appeared as one of the bridesmaids in *The Beloved* (fig. 8) and in 1867 was the model for *Joli Cœur* (Manchester City Art Gallery) and *A Christmas Carol* (fig. 10).

Ruth Herbert was the first to fulfil Rossetti's quest for the perfect combination of spiritual and sensual beauty. She was an actress, who had made her London début in 1855 at the Strand Theatre. Rossetti obtained a sitting from her in the summer of 1858, which he recorded ecstatically:

> I am in the stunning position this morning of expecting the actual visit . . . of a model whom I have been longing to paint for years – Mrs Herbert of the Olympic Theatre – who has the most varied and highest expression I ever saw in a woman's face, besides abundant beauty, golden hair, etc. . . . O my eye! She has sat to me now . . .[3]

For about one year Ruth Herbert remained his favourite model and her head was used for *Mary Magdalene at the Door of Simon the Pharisee* (cat. 30).

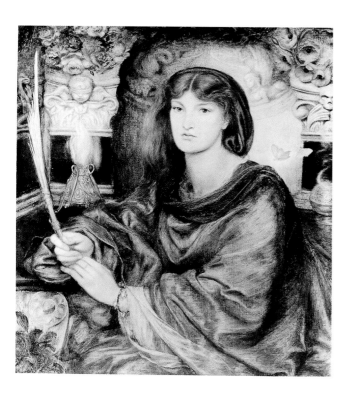

Fig. 12 Dante Gabriel Rossetti,
Sibylla Palmifera, 1866–70
Lady Lever Art Gallery,
Port Sunlight

She was described by her fellow actress Ellen Terry as 'very tall, with pale gold hair and the spiritual, ethereal look which the aesthetic movement loved'.[4] Rossetti's portraits of her established the characteristics of the voluptuous and inscrutable stunner that he would paint for the next decade and beyond. However, he rarely saw her after 1860.

Fanny Cornforth 'amused and satisfied a part of him which craved and found no satisfaction elsewhere. She appealed to his hearty good humour and love of robust jocularity. She was the perfect antidote to his Gothic fancies, his sighing after blessed damsels in abstract heavens, for she was real – flesh and blood.'[5] Cornforth appeared as the sensuous temptress in *Fazio's Mistress* (fig. 3), as the sleazy slut in *Woman combing her Hair* (cat. 33) and as the sultry siren in *The Blue Bower* (cat. 8). She was also the original model for *Lady Lilith* (cat. 6), but Rossetti substituted the more refined features of his new enthusiasm, Alexa Wilding, when his patron, Frederick Leyland, found the work too earthy.

Wilding, who became one of his favourite models, was a dressmaker, with ambitions to be an actress, whom he had seen one evening in the Strand in 1865. Impressed by her beauty, he asked her to pose for him the next day. She agreed, but did not arrive as arranged. Weeks later he saw her again, and, jumping from the cab in which he was riding, took her by the arm and led her back to his studio. He feared that other artists would try to obtain her services as a model and so entered into an arrangement by which he would pay her a weekly fee to sit to him exclusively. She was described by his assistant, H. Treffry Dunn, as having

> . . . a lovely face, beautifully moulded in every feature, full of quiescent, soft, mystical repose that suited some of his conceptions admirably, but without any variety of expression. She sat like a Sphinx, waiting to be questioned, and with always a vague reply in return . . . But she had a deep well of affection within her seemingly placid exterior . . . he was struck with her beautiful face and golden, auburn hair. It was the very type of face he had been seeking so long.[6]

Wilding was the model for some of Rossetti's finest works of the later 1860s and early 1870s, including *Monna Vanna* (cat. 9), *Regina Cordium*

(fig. 11), *Sibylla Palmifera* (fig. 12), *Veronica Veronese* (cat. 10) and *La Ghirlandata* (cat. 11). Rossetti paid her an annual retainer and the bond between them was lasting. 'She was one of the few Maries of the sepulchre who journeyed to Birchington-on-Sea when she could ill afford it so that she might place a wreath on Rossetti's grave.'[7]

The enduring love of Rossetti's later years was Jane Burden, whom he met at Oxford in 1857 – two years before she married William Morris. Tall and stunningly attractive like Lizzie Siddal, she too became a semi-invalid in later life. Her features were described thus by William Michael Rossetti:

> Her face was at once tragic, mystic, passionate, calm, beautiful and gracious – a face for a sculptor and a face for a painter – a face solitary in England and not at all like that of an Englishwoman . . . Her complexion was dark and pale, her eyes a deep penetrating grey, her massive wealth of hair gorgeously rippled and tending to black.[8]

Burden was the model for the head of the Virgin in *The Seed of David* in 1858. In July 1865 Rossetti posed her for a series of photographs in the garden at 16 Cheyne Walk, and the following year he painted her portrait (Society of Antiquaries, Kelmscott Manor). Soon afterwards he began *La Pia de' Tolomei* (Spencer Museum of Art, University of Kansas), completed in 1880, using her as his model. This sad tale from Dante's *Purgatorio*, of a heroine who died directly or indirectly at her husband's hands, was the first in a series of paintings in which Rossetti fictionalized his own perceptions of Jane Morris as infinitely desirable but unattainable through entrapment in a loveless marriage. Her mood is of extreme melancholy, combining the sensuous with the mystic.

In 1869 he began another series devoted to her: drawings, pastels and a painting on the theme of Pandora, the classical heroine whose box released all the world's evils, leaving only hope – an ironic reminder of the hopelessness of his own position. Jane Morris was also his model for eight versions of *Proserpine* (cat. 12 and fig. 13) and for *Mariana*, where, in an amalgam of Shakespeare and Tennyson, she is shown incarcerated in a moated grange, waiting hopelessly for her lover's return (fig. 14). The intensity of his yearning for her emerges in a letter of February 1870:

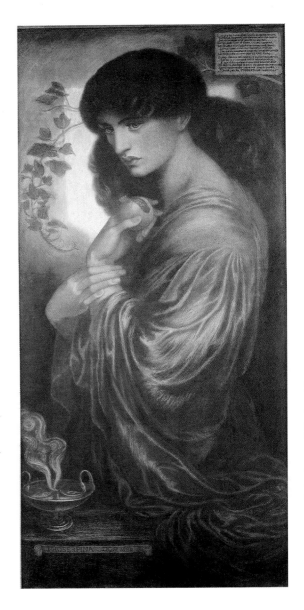

Fig. 13 Dante Gabriel Rossetti, *Proserpine*, coloured chalks on paper, 1880
Peter Nahum, London

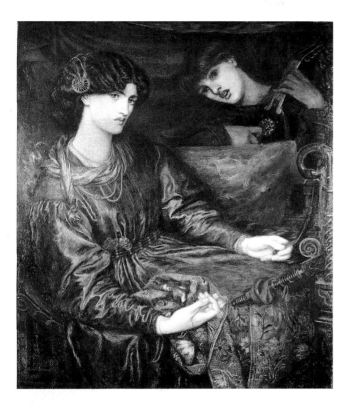

Fig. 14 Dante Gabriel Rossetti,
Mariana, 1870
Aberdeen Art Gallery and
Museums

No-one seems alive at all to me now, and places that are empty of you are empty of all life . . . You are the noblest and dearest thing that the world has had to show me, and if no lesser loss than the loss of you could have brought me so much bitterness I would still rather have this to endure than have missed the fullness of wonder and worship which nothing else could have made known to me.[9]

In July 1871, Rossetti and Morris jointly leased Kelmscott Manor in Oxfordshire, where Rossetti lived, mainly in Morris's absence, until the summer of 1874. He made many more paintings of Jane Morris, including *Astarte Syriaca* (1875–7, Manchester City Art Gallery), *La Donna della Finestra* (1879, Fogg Art Museum, Cambridge, Massachusetts) and *Mnemosyne* (1881, Delaware Art Museum, Wilmington). Together these express the whole range of Rossetti's feelings towards her, from the deserted and estranged wife in *La Pia* to the hopeful Pandora, from the vision of Proserpine, let free in the light for a season, to the goddess of carnal love in *Astarte Syriaca* and *Mnemosyne*, where memory is transformed by Love into Art.[10]

All these women and others, such as Ada Vernon, Marie Stillman, Aglaia Coronio and Maria Zambaco, were inspirations to Rossetti during the 1860s. His acute susceptibility to their beauty is vividly described by Mrs Gaskell:

It did not signify what we are talking about or how agreeable I was; if a particular kind of reddish brown, crepe wavy hair came in, he was away in a moment struggling for an introduction to the owner of said head of hair. He is not as mad as a March hare, but hair-mad.[11]

Rossetti's overwhelmingly literary subject-matter is a sign of his own deep roots in literature. He regarded himself as primarily a poet and only secondarily a painter. This was indicated clearly in a letter to his friend Gordon Hake in the wake of the publication of his *Poems* in 1870:

My own belief is that I am a poet (within the limit of my powers) primarily, and that it is my poetic tendencies that chiefly give value to my pictures: only painting being what poetry is not – a livelihood, I

have put my poetry chiefly in that form. On the other hand, the bread-and-cheese question has led to a good deal of my painting being pot-boiling and no more – whereas my verse, being unprofitable, has remained (as much as I have found time for) unprostituted.[12]

Many of his paintings – including *Venus Verticordia, The Blue Bower, Lady Lilith, Pandora* and *Proserpine* – were accompanied by sonnets, with verses often inscribed on their frames. His favourite poets at this time were Tennyson, Robert Browning, Swinburne and Morris.[13] On a personal level he found Tennyson distant, but he and Browning became close in 1855 and when he visited Paris that year, they toured the Louvre together, Rossetti declaring that Browning's knowledge of early Italian art was 'beyond that of everyone I ever met'.[14] He particularly admired Browning's poems on Italian Renaissance artists when they appeared in *Men and Women* in 1855. His friendship with Swinburne was formed at Oxford in 1857, the same year that he met Morris there. Swinburne published his plays *Rosamund* and *The Queen Mother* in 1860 with a dedication to Rossetti and the two remained close throughout the 1860s. In 1862 Swinburne established himself in rooms at Cheyne Walk, which he occupied for about two years and where much of his best work was written, including his verse drama *Atalanta in Calydon*, published in March 1865 (see fig. 15). In his *Notes on the Royal Academy Exhibition, 1868* he eulogized Rossetti's paintings *Lady Lilith* and *Venus Verticordia* enthusiastically: 'Among the many great works of Mr D. G. Rossetti, I know of none greater than his two latest. These are types of sensual beauty and spiritual, the siren and the sibyl.'[15] Swinburne also acted as adviser on numerous occasions to Rossetti over his poems and, on their publication in 1870, praised them fulsomely.

Rossetti's sensual depictions of women developed from the mid-Victorian genre scenes that had originated in the illustration of books of beauty and annuals such as *The Keepsake* in the 1830s and 1840s. Twenty years on, Richard Redgrave, Alfred Elmore and others continued to show single 'beauties' in swoony reverie over affairs of the heart or hearth. The settings were more or less imaginary, the titles sentimental, such as 'Loving Thoughts', 'The Ear-ring' or 'Lost in Thought'. Closely

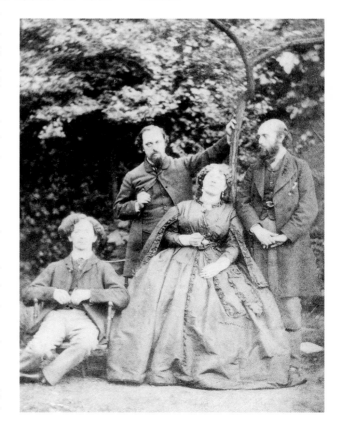

Fig. 15 William Downey, *Swinburne, Rossetti, Fanny Cornforth and William Michael Rossetti in the Garden of Tudor House,* photograph, *c.* 1863, National Portrait Gallery, London

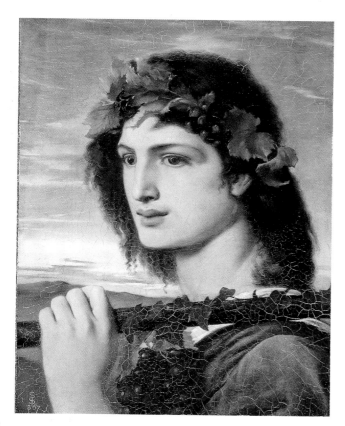

Fig. 16 Simeon Solomon, *Bacchus,* 1867, Birmingham Museums and Art Gallery

related to this genre were William Etty's depictions of musical scenes of dalliance, often in Renaissance costume, such as *The Duet* (Tate Britain), which may have influenced Rossetti after its showing at the International Exhibition of 1862. Yet the ethos of Rossetti's women of the 1860s is entirely different from such maudlin costume pieces; they stand out from these fancy pictures by their reduction in narrative content and their emphasis on more abstract qualities. Rarefied as they are, idealized and often medievalizing, their frank appreciation of female charms has something in common with contemporary French paintings by Courbet, Manet and others of the avant-garde. Courbet's toilette picture *Jo, The Beautiful Irish Girl* (cat. 17) was clearly painted in the knowledge of Rossetti's *Fazio's Mistress* (fig. 3), yet Rossetti's opinion of the French school in the 1860s was not complimentary. Writing of his visit to Paris in 1864, he said: 'There is a man named Manet (to whose studio I was taken by Fantin), whose pictures are for the most part mere scrawls, and who seems to be one of the lights of the school. Courbet, the head of it, is not much better.'[16] Although he is likely to have seen Manet's *Olympia* and other icons of modernity, Rossetti was highly critical of what he took to be the unfinished and 'lazy' technique of the French artists. As a colourist, and a worshipper of women's beauty, his sympathies were with Delacroix, whose *Women of Algiers* and other key works were in the Delacroix Memorial Exhibition at the Société Nationale des Beaux-Arts that he was in Paris to see.

Rossetti's links with French literature were centred upon Baudelaire and Gautier, knowledge of whom filtered into Britain during the 1860s via Whistler and Leighton, who had lived in Paris. Baudelaire's masterpiece *Les Fleurs du Mal* was published in 1857, Gautier's, *Émaux et camées*, having appeared the previous year. Both poets also wrote art criticism, their accounts of the Paris Salon together forming the best history of French painting of the day. Their ideas were to shake the preconceptions of Victorian art to their foundations by insisting that the primary concern of art should be with formal rather than narrative or moral values. The phrase 'art for art's sake' first appeared in English in Swinburne's *William Blake* of 1868 and was used in October that year by Walter Pater in a review of William Morris's poetry in *The Westminster Review*. The new ideal was elegantly expressed by Swinburne, who, in his review of the Royal Academy exhibition of 1868,

described Albert Moore's picture *Azaleas* as 'to artists what the verse of Théophile Gautier is to poets; the faultless and secure expression of an exclusive worship of things formally beautiful . . . its meaning is beauty; and its reason for being is to be.'[17] Abstract beauty was seen as closely analogous to music, a notion memorably formulated by Walter Pater in his essay, *The School of Giorgione*, published in 1877, but possibly written much earlier. 'Art,' he proclaimed, 'is . . . always striving to become a matter of pure perception, to get rid of its responsibilities to its subject or material . . . It is the art of music which most completely realizes this artistic ideal, this perfect identification of matter and form . . . Therefore to the condition of its perfect moments, all the arts may be supposed constantly to tend and aspire. In music . . . is to be found the true type or measure of perfected art.'[18]

During the 1860s Rossetti fell increasingly under the influence of the Venetian Cinquecento. Pictures by Venetian masters were slowly entering the national collections during his formative years. Giovanni Bellini's *Doge Loredan* was acquired by the National Gallery in 1844 and his *St Dominic* was purchased for the South Kensington Museum in 1856. By 1853 there is visual evidence of his interest in Venetian Renaissance painters. A drawing of that date, *Giorgione painting* (Birmingham Museums and Art Gallery), shows the artist painting a female model with the features of Lizzie Siddal. The following year Rossetti declared colour to be an indispensable ingredient in the best art, and cited Titian as his prime example.[19] By 1860 his preference for Venetian painting was marked and during his honeymoon in Paris that year he showed particular admiration for Titian and Veronese at the Louvre. Rossetti's first and most vital essay in the Venetian style was *Bocca Baciata* (cat. 1), completed in October 1859 'in late 16th century costume' and painted in oils in a new, 'rapid' style. This marks a deliberate change from the works of the previous decade. Rossetti described his aims in a letter to William Bell Scott written in November 1859 after he had completed *Bocca Baciata*:

> I have painted a half figure in oil in doing which I have made an effort to avoid what I know to be a besetting sin of mine, and indeed rather common to P.R. painting – that of stippling on the flesh. I have succeeded in quite keeping the stippling process at a distance this time, and am very desirous of painting, whenever I can find leisure and opportunity, various figures of this kind, chiefly as studies of rapid flesh painting . . . Even among the good old painters, their portraits and simpler pictures are almost always their masterpieces for colour and execution.[20]

Fig. 17 Dante Gabriel Rossetti,
The Bower Meadow, 1871–2
Manchester City Art Gallery

Rossetti himself described *Bocca Baciata* as having 'a rather Venetian aspect'. The model, Fanny Cornforth, was one of the contributory factors to this change of style, her golden-red hair and coarse good looks bringing to mind the fancy portraits of beauties by Titian and his circle (cat. 14). She became its muse, in succession to Lizzie Siddal, whose ethereal qualities had inspired his Dantesque and medieval works.

Venetian art, music and colour became interlinked in British painting of the 1860s. Burne-Jones helped to focus attention on Venetian prototypes. In September 1859 he made a drawing of Titian's *La Bella* in the Pitti Palace and during the 1860s he proceeded to execute a magnificent series of haunting watercolours and oils, set in romantic landscapes and often combining a musical theme, emotional tension and evening light to create a world of nostalgia and yearning – idylls whose rich atmosphere and glowing colours testify to their origins in Giorgione. Ruskin had written in the third book of *The Stones of Venice* (1853) 'when an artist touches colour, it is the same thing as when a poet takes up a musical instrument'.[21]

A group of Rossetti's watercolours of 1857–8, including *The Blue Closet*, seem intended to symbolize the association of colour and music (cat. 28). While the embellishments are lavishly medieval, the subject is the product of his imagination, with no story and no message other than decorative brightness. This combination of the associative and decorative was a point of departure for the Aesthetic Movement. Burne-Jones's career virtually stems from these watercolours and Morris and Swinburne both wrote poetry based upon them.[22] Later Rossetti was to describe *Fazio's Mistress* as 'chiefly a piece of colour' and in it he seems to have used the Indian reds favoured by Titian.[23] In 1869 he went so far as to rename the work 'Aurelia', because of the golden-red hair of the model.[24] Four years later he renamed *Monna Vanna* (cat. 9) 'Belcolore' after retouching parts of it at Kelmscott Manor, on the grounds that this title was more in keeping with 'so comparatively modern-looking a picture'. Colour is in the ascendant in *The Blue Bower*, which may be seen as a kind of tone poem in the closely related hues of blue and green. Its greatest *raison d'être*, apart from Rossetti's delight in the beauty of his model, are the subtle colour harmonies that dominate the composition. Once more the artist is borrowing from Venetian

Renaissance painters, but he excels the mere opulence of their palettes by allowing his liquid and richly hued surfaces to form an independent theme, letting the colours assume a life of their own. This tonal sensitivity is advanced for the Victorian period because of the way in which it reminds the viewer that colour is as important as form.

In 1862 the largest display of Japanese art ever seen in Europe went on show at the International Exhibition in London – 623 items in all, ranging from prints and books to bronzes, porcelain, lacquer and enamelware. Like many of his contemporaries, Rossetti was drawn to these items from a newly revealed world, which seemed to provide a parallel with the ideal medieval society he had been seeking to create during the 1850s. He was in the vanguard as a collector of Oriental works of art and began to use Oriental pieces as properties in his painting from the early 1860s. It has been noted that Japanese influence may be detected in book designs of 1861 and 1862 and in a sofa designed for Morris, Marshall, Faulkner and Company, which was itself exhibited at the 1862 exhibition.[25] Rossetti's interest in the Orient was stimulated and focused upon Japan by the arrival in Chelsea of Whistler in 1863. Whistler came from Paris, where among his close associates he had numbered the painters Fantin-Latour, Bracquemond and Manet – all admirers of Japanese art. William Michael Rossetti, himself a fellow enthusiast, recorded that 'it was Mr Whistler who first called my brother's attention to Japanese art: he possessed two or three woodcut blocks, some coloured prints, and a screen or two.'[26] By the mid-1860s Rossetti and Whistler were both drawing inspiration from Japanese themes, but their approaches were different. Whereas Whistler showed a real yearning for the Far East (cats. 18 and 19), Rossetti depicted an exotic world of his own invention, concentrating his interest on colour and the decorative quality of Japanese objects. This can be seen in *The Beloved*, where the central female figure wears an ornate kimono – but in a most un-Japanese way, primarily to give a rich and luxurious texture to the painting (fig. 8). Although a pioneer of *japonisme*, Rossetti was not alone in his enthusiasm. During the 1860s Japanese art was collected by the architects William Burges and E. W. Godwin and influenced even conservative academicians such as E. J. Poynter, who designed a Japanese fireplace during that period. Leighton was another collector of Japanese art and incorporated a golden screen with flying cranes into his *Mother and Child* of 1864–5 (Blackburn Museum and Art Gallery). Similar screens featured prominently in works by Rossetti's circle, for example Frederick Sandys's *Medea* (cat. 20) and his sister Emma Sandys's *Portrait of a Woman in a Green Dress* (Private Collection) of about 1870. In 1863 William Michael Rossetti wrote 'Japanese Woodcuts: An illustrated Book from Japan' for *The Reader* – probably the first article about the

printmaker Hokusai to appear in Britain. Three years later it seems that both brothers may have met Japanese students from Satsuma (Kagoshima) through George Price Boyce, a fellow enthusiast.[27] By the end of the decade Rossetti had progressed beyond using Japanese objects as mere properties in his paintings and was also beginning to use Japanese compositional devices such as scroll signatures (cat. 38).

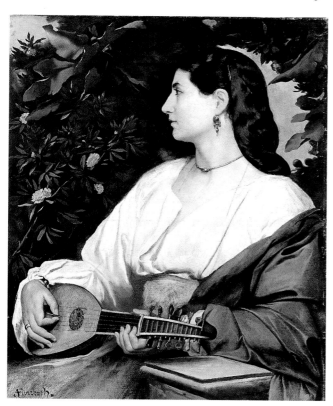

Fig. 18 Anselm Feuerbach, *The Mandolin Player*, 1865, Hamburger Kunsthalle

Rossetti's fascination with the predatory aspect of female sexuality developed rapidly during the 1860s. *Fair Rosamund* (cat. 2), while alluring as an icon of female beauty, presents a figure more of pathos than seduction, but the worship of the eternal feminine was given a new dimension of menace by the watercolour of *Lucrezia Borgia* (cat. 31). According to legend Lucrezia Borgia (1480–1519) was notorious for her wantonness, vice and crime, including incest. She was the illegitimate daughter of Pope Alexander VI and sister of Cesare Borgia, both of whom played a part in the murder of her second husband, Alfonso of Aragon. Here she is depicted as the protagonist. The work demonstrates a new taste for sixteenth-century themes that was emerging in Rossetti's circle, almost entirely superseding his medieval ideals of the 1850s. Renaissance crimes were becoming chic, especially when committed 'against nature' by rich and powerful women. The main impetus seems to have come from Swinburne's enthusiasm for Elizabethan dramatists and his delight in the connections between eroticism and pain. He once wrote of Lucrezia Borgia's 'holy family', in whom he had taken 'the deepest and most reverential interest' since childhood. Rossetti's watercolour was painted in 1860–1 and finds a contemporary parallel in Burne-Jones's *Sidonia von Bork* (Tate Britain), which likewise combined themes of beauty, evil and magic. The subject was taken from Wilhelm Meinhold's German romance, which tells the story of a well-born Pomeranian girl who was finally burnt as a witch in 1620. So beautiful that all who saw her fell in love with her, she was also deeply vicious, committing untold cruelty upon the men who fell under her spell and eventually bewitching the ruling house of Pomerania to extinction. Rossetti's fascination with the sexual and murderous misdeeds of Lucrezia Borgia even overcame his indifference to music, for he greatly admired Donizetti's opera based on Victor Hugo's tragedy, which had frequent performances at Covent Garden during the early 1860s. The thrilling paradox of beauty mingled with evil,

cruelty with sensuality and invitation with menace helped him to define the instinct towards submission to female sexual power that is interwoven with the cult of the 'stunner'. In 1863 he painted the tiny but dazzling *Helen of Troy*, whose deceitful beauty lay at the root of the Trojan Wars (cat. 4). The secrets of her power were defined by Rossetti's inscription on the back of the panel: 'Destroyer of ships, destroyer of men, destroyer of cities.' The following year his true sensuality burst through with *Venus Verticordia* (cat. 5). One of only two nude female figures among his paintings, the conjunction of soft exposed breast and sharp, pointed arrow read as a symbol of unrestrained but cruel sexuality. This theme reaches a climax with the witch-beauty, *Lady Lilith* (cat. 6).

During the 1860s Rossetti achieved success through a style and subject matter that could hardly be more remote from his Pre-Raphaelite roots: not in the field of Ruskinian truth to nature but in an esoteric world of the imagination. The distance he had travelled from the social realism of his ill-fated *Found* (fig. 2), insistently detailed and overlaid with moralizing, may be measured by comparing it with pictures of about 1870 such as *The Bower Meadow* (fig. 17) and *La Ghirlandata* (cat. 11). In these, colour, mood and moral neutrality prevail. Escapism played a significant part in this shift, not least from the 'vulgar naturalism, the common realism, which is applauded by the uneducated multitudes who throng our London exhibitions'.[28] At a deeper level the horrors of the industrial age were compounded in the late 1850s by social uncertainty. In particular the beginnings of the women's emancipation movement began to affect the conventions of male–female relations with the first petition for women's suffrage in 1866. The subsidiary role of women began to be challenged, together with mid-Victorian stereotypes including those of the 'angel in the house' and the 'fallen woman'. Rossetti's response to these changes is complex, but they must have played a part in the genesis of his mystic-erotic female portraits.

His influence on European painting over the next forty years is pervasive. There are parallels in Corot's series of life-size half-lengths of about 1870, such as *Sybil* (Metropolitan Museum of Art, New York), in which he experimented with colour ranges and harmonies. In Germany, Anselm Feuerbach's obsessive portraits of Nanna from 1860 to 1865 reflect Rossetti's serial celebrations of Fanny Cornforth, and his *Mandolin Player* silhouettes her against a rich background of fig tree and pomegranate flowers in a way that recalls Venetian Renaissance beauties (fig. 18). Like *The Blue Bower* it was inspired by the artist's mistress and insists upon beauty for its own sake rather than for any narrative purpose. The Swiss painter Arnold Böcklin expressed his heightened Romanticism and poetry in the 1860s and 1870s in a series of female half-lengths based on his wife and daughter. *The Muse*

of Anacreon is particularly close to Rossetti in its musical subject and symbolic allusions to love and beauty (cat. 25). Starting in the 1850s, continental art critics such as Prosper Mérimée and Fernand Khnopff reviewed a number of Pre-Raphaelite exhibitions in England.[29] By the late 1860s Ernest Chesneau and Philippe Burty were focusing on Rossetti, even though his work was not exhibited publicly in France. Their interest was partly stimulated by his poetry, which was compared with that of Baudelaire, himself an admirer of Pre-Raphaelite art. By the 1880s Rossetti was the most publicly venerated British artist in Europe along with Burne-Jones. In 1887 Joséphin Peladan published a French translation of Rossetti's poems entitled *La Maison de Vie* and Edouard Rod published two articles praising *Beata Beatrix* and other works.[30] In 1891 a parallel between the art of Rossetti, Burne-Jones and Khnopff was drawn in an influential article by W. Shaw-Sparrow in *The Magazine of Art*.[31] By then Frederick Hollyer's photographic reproductions of Rossetti's works were available for purchase by mail order and an exhibition of them was held in Belgium in 1891. It should not, therefore, be surprising to find echoes of Rossetti in later painters as diverse as Gauguin, Maurice Denis, Khnopff, Hodler, Klimt and Alphonse Mucha.

Rossetti's concentration upon mood, bringing image and symbol together to present a psychological state independent of any narrative element, was his most significant contribution to later Symbolist painting. Undoubtedly, his central image in this respect was *Beata Beatrix*, where, in celebrating his wife Elizabeth Siddal at the point of death, he combined the fleshly and the spiritual, anticipating two of the central strands of Symbolism at its apogee in the 1880s and 1890s. In Britain it was his mystical idealism that inspired Burne-Jones and later followers such as Kate Bunce (cats. 26 and 42), but internationally his sadistic predators such as *Lady Lilith* evinced a host of *femmes fatales* who preyed upon men. The Sphinx, Salome and others feature prominently in the work of Gustave Moreau, the most distinctive of the French Symbolists and a fervent admirer of Rossetti. The most extreme instance is Edvard Munch's *Madonna* of 1895, whose decadent explicitness ultimately derives from the self-absorbed women created by Rossetti thirty years earlier (cat. 43).

NOTES

1. Doughty and Wahl, II, 1965, p. 509; letter to his aunt, Charlotte Lydia Polidori, 25 June 1864.
2. John Henry Middleton, quoted in Wilfred Scawen Blunt, *My Diaries*, I, New York, 1921, p. 72.
3. Surtees, p. 64.
4. Cited in V. Surtees, '"Beauty and the Bird": a new Rossetti drawing', in *Burlington Magazine*, CXV, February 1973, p. 85.
5. P. F. Baum (ed.), *Dante Gabriel Rossetti's Letters to Fanny Cornforth*, Baltimore, 1940, p. 126.
6. H. T. Dunn, *Recollections of Dante Gabriel Rossetti and his Circle*, ed. R. Mander, Westerham, 1984, p. 45.
7. Ibid.
8. W. M. Rossetti, *Dante Gabriel Rossetti – His Family Letters with a Memoir*, I, London, 1895, p. 199.
9. J. Bryson and J. C. Troxell, *Dante Gabriel Rossetti and Jane Morris, Their Correspondence*, Oxford, 1976, p. 68.
10. A. C. Faxon, 'Rossetti and his Models', *The Journal of Pre-Raphaelite Studies*, v. 2, May 1985, p. 63.
11. E. C. Gaskell, Letter to Charles Eliot Norton, October 1859, cited in A. Rose, *Pre-Raphaelite Portraits*, Oxford, 1981, p. 102.
12. Doughty and Wahl, II, pp. 850–1.
13. Ibid., p. 800.
14. Doughty and Wahl, I, p. 280.
15. Academy Notes, p. 46.
16. Doughty and Wahl, II, p. 527; letter to his mother, 12 November 1864.
17. Academy Notes, p. 32.
18. W. Pater, *The Renaissance, Studies in Art and Poetry*, London, 1922, pp. 138–9.
19. Doughty and Wahl, I, pp. 196–7; letter to Francis MacCracken, 14 May 1854.
20. Ibid., p. 319.
21. *The Works of John Ruskin*, ed. E. T. Cook and A. Wedderburn, XI, London, 1904, p. 219.
22. A. Staley, 'The Condition of Music', in *The Academy: Five Centuries of Grandeur and Misery, from the Carracci to Mao Tse-Tung*, ed. T. B. Hess and J. Ashbery, *Art News Annual*, XXXIII, New York, 1967, p. 86.
23. Letter to Ellen Heaton, 25 October 1863, cited in Surtees, p. 92.
24. Letter to George Rae, 21 August 1869, Ms in Lady Lever Art Gallery, Port Sunlight; cited in D. S. Macleod, 'Dante Gabriel Rossetti and Titian', *Apollo*, CXXI, January 1985, p. 39, n. 7.
25. T. Sato and T. Watanabe in exh. cat., *Japan and Britain: An Aesthetic Dialogue 1850–1930*, London, Barbican Art Gallery, 1991, p. 20.
26. W. M. Rossetti, *Some Reminiscences of William Michael Rossetti*, I, London, 1902, p. 276.
27. Tanita Hiroyuki, 'Rossetti and two Japanese Students from Satsuma – An unpublished letter of G. P. Boyce to W. M. Rossetti, *Bijutsushi Kenkyu (Art History Studies)*, December 1989, pp. 69–85; cited in exh. cat., *Japan and Britain*, p. 109.
28. *Art Journal*, X, 1871, p. 177.
29. S. P. Casteras and A. C. Faxon (eds), *Pre-Raphaelite Art in its European Context*, Cranbury, NJ, 1995, p. 28. Much of the following information on European awareness of Rossetti is drawn from the essays by Susan P. Casteras and Sarah P. Smith in this volume.
30. E. Rod, 'Les Pré-Raphaélites anglais', *Gazette des Beaux-Arts*, 2e période, XXXVI, November 1887, pp. 177–195 and 399–416.
31. W. Shaw-Sparrow, 'Fernand Khnopff', *The Magazine of Art*, XIV, 1891, p. 43.

The Catalogue

Some works are exhibited at Birmingham or Williamstown only.
This is indicated throughout the catalogue by the
abbreviations [BI] or [CAI] respectively.

1 *Bocca Baciata*, 1859

Oil on wood, 32.2 × 27.1 cm (12⅝ × 10⅝ in)
Signed with monogram lower left: GCDR
Museum of Fine Arts, Boston [CAI]

Bocca Baciata represents a dramatic turning point in Rossetti's career and establishes the single figure format that was to become his norm in the 1860s. It marks his return to oil as a medium and the introduction of a new type of model, whose features include a sweeping neck, cupid's-bow lips and cascading hair. The Arthurian and Dantesque subjects of the 1850s with their small, angular figures and medieval settings are rarely seen from now on. Rossetti's new woman, sensual and voluptuous, owes her origins to Fanny Cornforth, the model here, who replaced Lizzie Siddal as his main inspiration at this time and had probably just become his lover. She is seen against a background of marigolds, which in Rossetti's language of flowers symbolize grief and regret – perhaps for his own loss of innocence. On the back of the picture is written in Italian the couplet from Boccaccio that gave the work its title: 'Bocca baciata non perde ventura, anzi rinnova come fa la luna.' This may be translated as: 'The mouth that has been kissed loses not its freshness; still it renews itself even as does the moon.'

The style of this small panel is Venetian, as Rossetti himself remarked. This includes both the costume and the succulent flesh, painted rapidly so as to avoid the painstaking techniques of early Pre-Raphaelitism. George Price Boyce took it over as a commission in July 1859. He may well have played a part in the conception of the work since he and his sister painted small decorative female heads themselves. In 1857 they bought from Millais two small head-and-shoulder portraits of Alice and Sophie Gray, which must have been known to Rossetti and prefigure *Bocca Baciata*. Rossetti, however, did not wish his picture to be considered a portrait, but, rather, an object of beauty in its own right, devoid of specific associations. *Bocca Baciata* may thus be taken as the first subjectless picture of the Aesthetic Movement. Nevertheless, when Holman Hunt saw it exhibited at the Hogarth Club in 1860 he had severe moral objections, criticizing it for 'gross sensuality of a revolting kind peculiar to foreign prints' and censuring Rossetti for 'advocating as a principle mere gratification of the eye'.[1] For the young Swinburne it was 'more stunning than can decently be expressed'.[2]

1. Letter to Thomas Combe, 12 February 1860, cited in Surtees, p. 69.
2. V. Surtees (ed.), *The Diaries of George Price Boyce*, Norwich, 1980, p. 89.

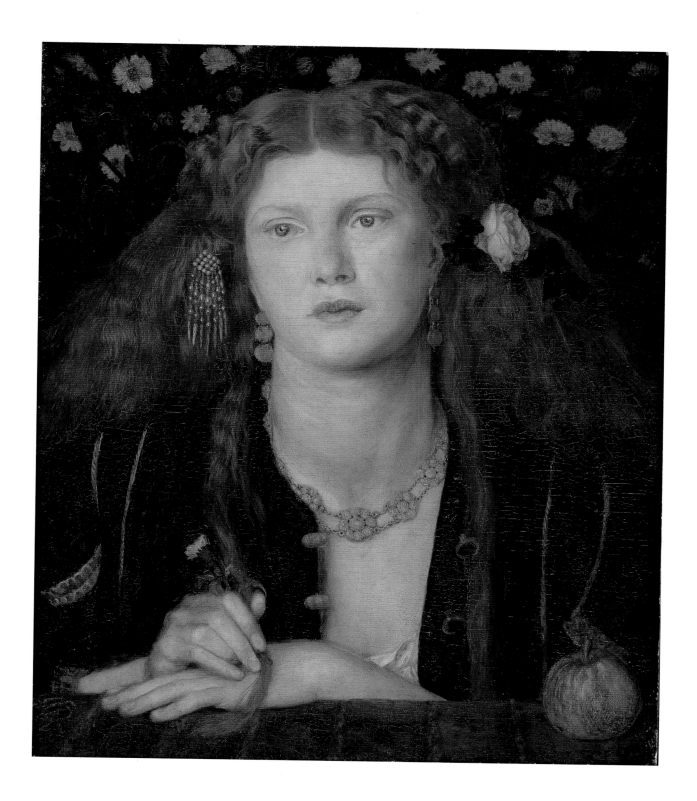

2 *Fair Rosamund*, 1861

Oil on canvas, 52 × 42 cm (20¹/₂ × 16¹/₂ in)
Signed with initials and dated lower right: D.G.R. 1861
National Museums and Galleries of Wales, Cardiff

The subject is taken from medieval history, the source most favoured by Rossetti during the preceding decade. Rosamund Clifford was the mistress of King Henry II (1133–89), who had a house constructed for her in a maze at Woodstock near Oxford. No one might visit her there except the king, but according to legend she was found by Henry's queen, Eleanor of Aquitaine, and murdered. The story was probably known to Rossetti through Thomas Percy's *Reliques of Ancient English Poetry*, published in 1765 and much admired by William Morris and Burne-Jones.

Rosamund is shown before a window of archaic bottle glass. On the sill that separates her from the world a red silken cord is attached to a golden peg in the form of a rose. Its agitation will indicate the king's approach; meanwhile, Rosamund waits in weary readiness. The rose, which is repeated in her hair and other parts of the picture, refers to her name – 'Rose of the World'. The crowned hearts that appear in the tiles of the sill are emblems of the king's love for her. Since the model is Fanny Cornforth, and the date of execution falls within Rossetti's brief marriage, the theme may imply that Cornforth was already his mistress and that his wife was bitterly jealous. However, the story of Rosamund was popular at this time and was treated by Frederick Sandys and Burne-Jones. Swinburne also wrote a play on it in 1860. Nostalgic in its references to the age of chivalry, it may be a reaction to growing contemporary demands for women's education and emancipation.

There is a preparatory drawing of Fanny Cornforth's head and shoulders in the Cecil Higgins Art Gallery, Bedford. It was probably this to which Rossetti was referring when he wrote to Alexander Gilchrist on 11 July 1861: '. . . have nearly finished the large head which I have made into *Fair Rosamund*.'[1] The frame is original, designed by Rossetti in his 'thumb-mark pattern'.

1. Doughty and Wahl, II, p. 412.

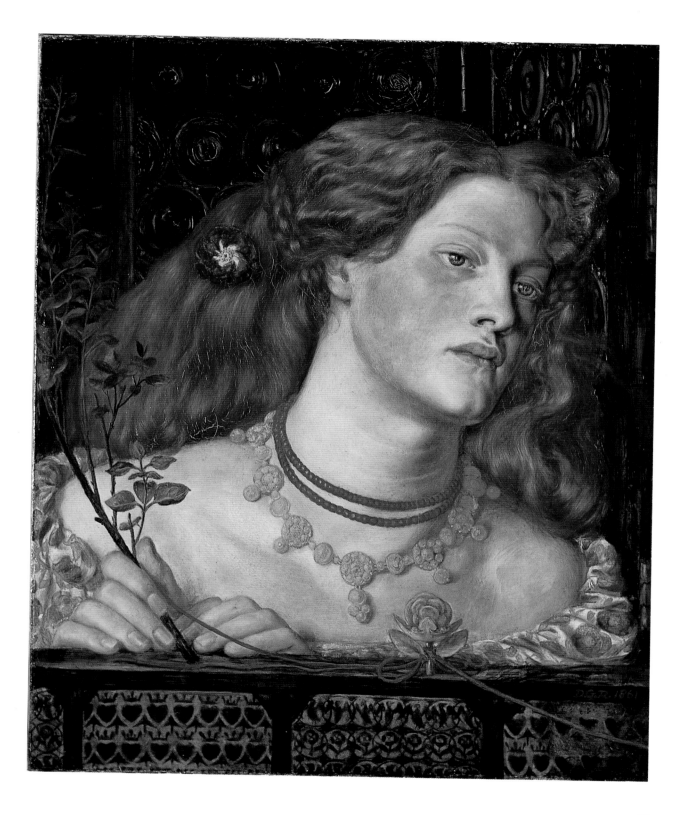

39

3 *Girl at a Lattice*, 1862

Oil on canvas, 29.2 × 26.3 cm (11^1/$_2$ × 10^3/$_8$ in)
Signed in monogram and dated, lower left: DGR 1862
The Syndics of the Fitzwilliam Museum, Cambridge [BI]

In the later 1850s Millais, Ford Madox Brown and others of the Pre-Raphaelite circle created a vogue for small-scale studies of the heads of women and children. Although they stressed attention to detail, these were essentially decorative in conception, with no clear narrative, moral or documentary purpose. Rossetti's jewel-like *Girl at a Lattice* is such a painting. Executed in May 1862 at Madox Brown's Hampstead house, where Rossetti was recovering from the shock of his wife's death, it depicts the Browns' Irish maid, whose expression seems to echo that of Lizzie Siddal. The following year Brown himself painted the same model in a similar composition, *Mauvais sujet* (unlocated).

Girl at a Lattice also typifies on a domestic scale the paintings of women begun in 1859 with *Bocca Baciata*, in which Rossetti deliberately restricted size and spatial recession in order to concentrate on arrangements of colour and rapid flesh-painting (cat. 1). Thus the brown-red tones of the wallflowers in the foreground are taken up in the girl's ruddy cheeks and coral necklace. The necklace was owned by Rossetti and, with its overtones of passion, was to become a favourite property of him and his circle. His employment of a window and ledge as framework for head and hands, perhaps based upon Dutch prototypes, had already featured in *Fair Rosamund* (cat. 2). In the present case it must have been taken from nature, since the ledge is clearly rotten. The prominent Staffordshire willow-pattern jug and bowl belonged to Brown, an enthusiastic collector of such cheap pottery, but they also prefigure Rossetti's fascination with Oriental blue-and-white porcelain, first apparent in *Woman combing her Hair* (cat. 33). *Girl at a Lattice* was admired and bought for £30 by Rossetti's friend and fellow artist George Price Boyce in May 1862. The thumb-mark pattern frame is original.

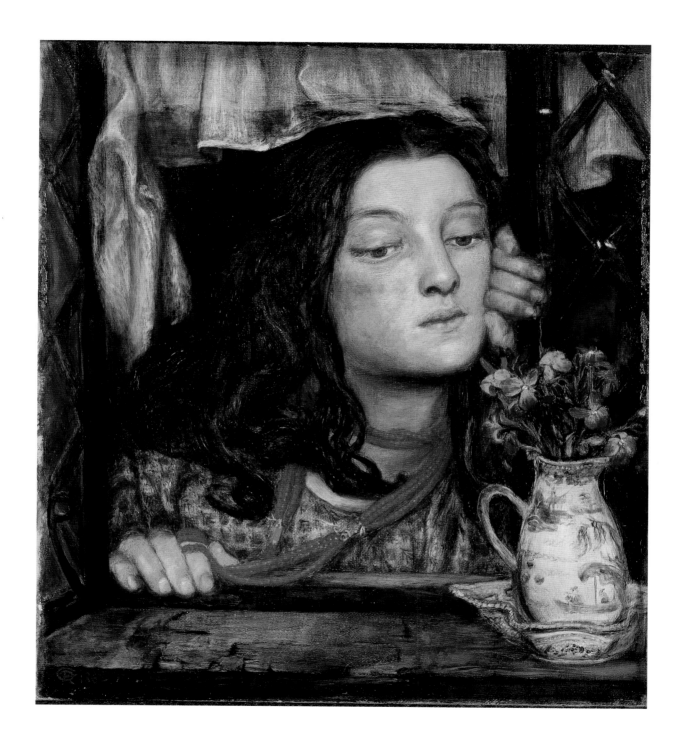

4 Helen of Troy, 1863

Oil on wood, 32.8 × 27.7 cm (13 × 11 in)
Signed in monogram and dated lower left: DGR 1863
Hamburger Kunsthalle

This riveting little picture embodies Rossetti's paragon of female allure, in stark contrast to his domestic *Girl at a Lattice* of the previous year (cat. 3). The most beautiful woman of the ancient world holds the viewer in a mesmerizing gaze as she points to the flaming torch at her throat, signifying the final destruction of Troy, seen blazing in the distance. It was Helen's irresistibility to men which led Paris to abduct her from Sparta and thus bring on the Trojan War. The work was punningly inscribed by Rossetti on the back, 'Helen of Troy, ἑλέναυς, ἑλανδρος, ἑλέπτολις (destroyer of ships, destroyer of men, destroyer of cities).'[1] As a figure from classical antiquity, Helen is unusual among Rossetti's works of the 1860s; the most obvious parallel is *Venus Verticordia* (cat. 5). In both cases he has distanced himself from any remnants of neoclassical grace and deliberately emphasized the emotional power of the figures. Among his contemporaries, however, there are numerous examples of the continuing classical paradigm of beauty, notably G. F. Watts's *Wife of Pygmalion* (cat. 23). Helen's cascade of hair, exotic costume and prominent jewellery anticipate later sensual works such as *Monna Vanna* (cat. 9) and the painting is particularly striking as an instance of Rossetti's saturated colours. The resulting intensity is all too fitting for this destructive temptress, forebear of numerous *femmes fatales* in later British and European art.

Rossetti's model was Annie Miller, a woman of humble origins discovered by Holman Hunt and used as the model for the kept woman in *The Awakening Conscience* (fig. 7). Unsurprisingly, Helen of Troy titillated the sado-masochistic fantasies of Swinburne, who rhapsodized over her 'Parian face and mouth of ardent blossom, a keen red flower-bud of fire, framed in broad gold of widespread locks, the sweet sharp smile of power set fast on her clear curved lips, and far behind her the dull flame of burning.'[2] Rossetti originally intended to use photographic aids for the background details. Writing to his mother, he asked for 'the photograph of *Old Cairo* which hangs in your parlour [and] any stereoscopic pictures . . . which represent general views of cities . . . or anything of a fleet of ships.'[3]

1. Aeschylus, *Agamemnon*, 688.
2. *Essays and Studies*, London, 1875, p. 99.
3. Doughty and Wahl, II, p. 479.

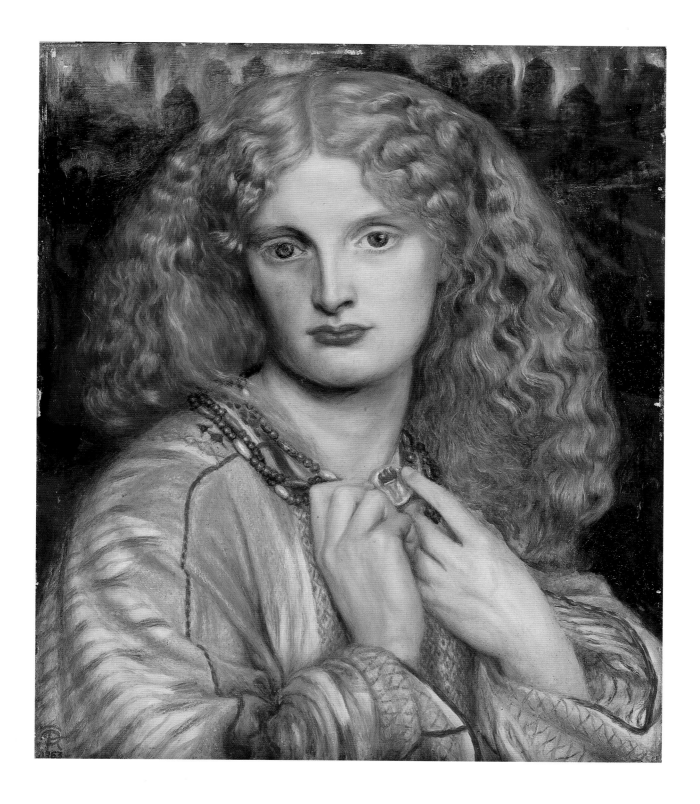

43

5 *Venus Verticordia*, 1864–8

Oil on canvas, 83.8 × 71.2 cm (33 × 27½ in)
Signed in monogram lower left: DGR
Russell-Cotes Art Gallery and Museum, Bournemouth

Rossetti began work on a large chalk study of this subject in 1863 (Faringdon Collection Trust, Buscot Park). According to his brother, the original model was a handsome cook almost six feet tall, but in January 1868 he repainted the face, substituting the features of Alexa Wilding. References to classical mythology abound, notably the prominent apple, which was awarded to Venus by Paris as a trophy of her beauty; the arrow, attribute of her son, Cupid; and the butterflies, symbolizing the souls of her lovers, already dead. The blue bird portends woe and was believed by the ancients to live for one day only. The title of the work means 'Venus, Changer of the Heart', and it is at her heart, beneath her exposed left breast, that Cupid's arrow points.

Venus Verticordia is one of only two nude female figures among Rossetti's completed paintings. Its overtly sexual nature was almost certainly influenced by Swinburne, with whom Rossetti was on intimate terms during the early 1860s. In 1866 the poet published his first series of *Poems and Ballads*, which took the public by storm. The overpowering setting of roses and honeysuckle impart a swooning heaviness to the atmosphere and Rossetti is known to have connected honeysuckle in particular with sexuality because of its form and its attractiveness to bees.[1] These overtones were not lost on Ruskin, hitherto a patron and supporter of the artist, who criticized the 'coarseness' of *Venus Verticordia* and, by implication, the dissoluteness of Rossetti's lifestyle.

The painting was commissioned in April 1864 but completed only in 1868 and sent to its buyer, John Mitchell of Bradford, in September of that year. The previous January Rossetti had written a sonnet for it, linking the subject with *Helen of Troy* (cat. 4):

> *A little space her glance is still and coy;*
> *But if she give the fruit that works her spell,*
> *Those eyes shall flame as for her Phrygian boy [Paris].*
> *Then shall her bird's strained throat the woe foretell,*
> *And her far seas moan as a single shell,*
> *And through her dark grove strike the light of Troy.*[2]

1. See Rossetti's poems *The Honeysuckle* and *Chimes* in W. M. Rossetti (ed.), *The Works of Dante Gabriel Rossetti*, London, 1911, pp. 199, 227.
2. Ibid., p. 210.

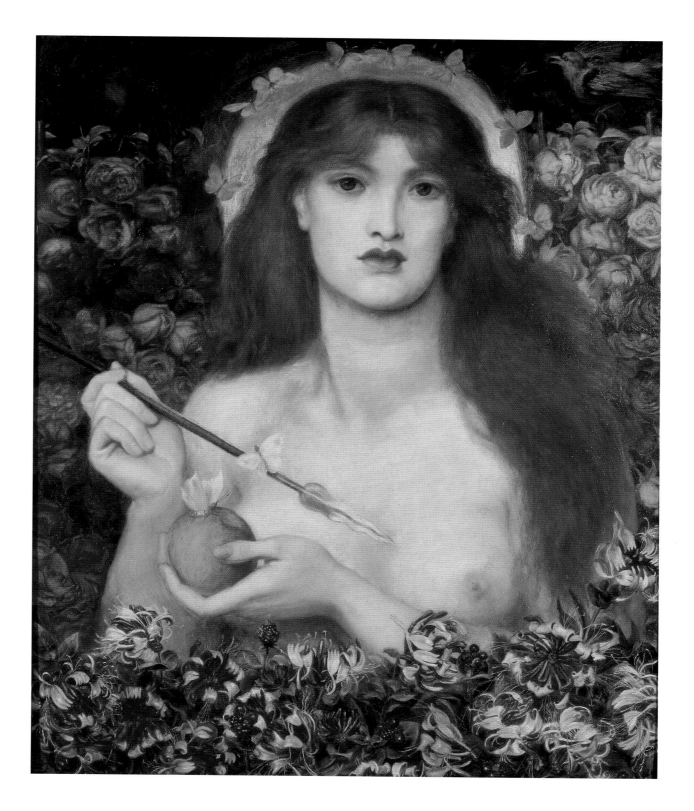

6 *Lady Lilith*, 1864–8

Oil on canvas, 97.8 × 85.1 cm (38$^{1}/_{2}$ × 33$^{1}/_{2}$ in)
Signed and dated centre left: D. G. Rossetti 1868
Delaware Art Museum, Wilmington [CAI]

Lilith originates in Talmudic and Assyrian legend as the witch-wife of Adam before he married Eve. Rossetti portrays her life-size as a soulless modern temptress, 'combing out her abundant golden hair . . . with that self-absorption by whose strange fascination such natures draw others within their own circle.'[1] His sonnet, *Eden Bower*, published in 1870, is quoted on the frame:

> *Of Adam's first wife, Lilith, it is told*
> *(The witch he loved before the gift of Eve)*
> *That, ere the snake's, her sweet tongue could deceive,*
> *And her enchanted hair was the first gold.*

He began the work in 1864 but made little progress until two years later. The mood is languorous and claustrophobic, the poppy in the Venetian glass symbolizing drowsiness and the abundant roses passion. These feelings accord well with the character of the original model, Fanny Cornforth, who is depicted in the related watercolour, *Woman combing her Hair* (cat. 33). However, in 1872–3 Rossetti substituted the more elegant features of Alexa Wilding at the request of the owner, F. R. Leyland, who deemed Cornforth too sensual and commonplace. An idea of the work's original appearance can be gained from a watercolour replica in the Metropolitan Museum of Art, New York.[2] Wilding was also the model of *Sibylla Palmifera* (fig. 12), which Rossetti began as an independent work in 1866 but turned into a pendant to *Lady Lilith*.

The motif of the woman combing her hair and contemplating her image was taken up by Courbet in *Jo, The Beautiful Irish Girl* of 1865 (cat. 17). As Rossetti's most extreme example of flowing, luxuriant hair, *Lady Lilith* also inspired Symbolist artists and eventually influenced the imagery of Art Nouveau. Its most threatening aspects, such as the presence of death suggested by the foxgloves and snuffed candles, and the reference on the frame to 'one strangling golden hair', made it a paradigm of the *femme fatale* and were later interpreted as negative comments on women's emancipation, which gathered pace in the 1860s and 1870s.

1. Doughty and Wahl, ii, p. 850; letter to Dr Thomas Hake, 21 April 1870.
2. Reproduced in Marillier, facing p. 133.

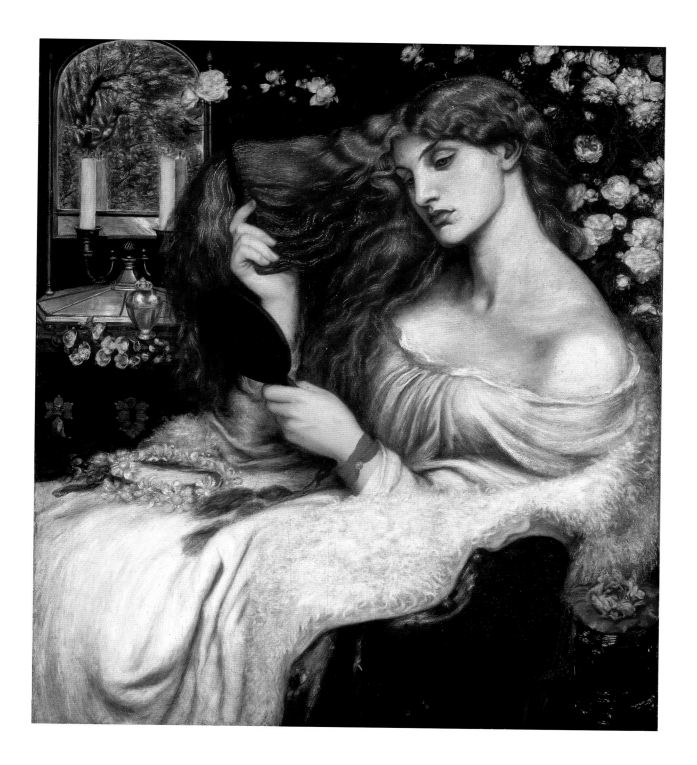

7 *Beata Beatrix*, 1880

Oil on canvas, 85 × 65.4 cm (33¹/₂ × 25³/₄ in)
Inscribed and dated lower left: D. G. Rossetti 1880
National Gallery of Scotland, Edinburgh

This is the last of six replicas of *Beata Beatrix* ('Blessed Beatrice') at Tate Britain, which was unavailable for this exhibition. The Tate version was begun in about 1864 and finished in late 1870. It was painted in memory of Rossetti's wife, Lizzie Siddal, who died from an overdose of laudanum in February 1862 (see also cat. 27). The theme is taken from Dante's *La Vita Nuova*, in which Rossetti's favourite poet describes his unrequited love and mourning for Beatrice Portinari. Rossetti had translated it into English and he identified closely with Dante's idealized love for Beatrice and sense of loss at her death.

Beatrice sits at a balcony receiving the message of her death from a heavenly dove – symbol of the Holy Spirit but also a reference to one of Rossetti's pet names for his wife, 'the dove'. Its redness is the colour of Love and in its beak is an opium poppy, traditional symbol of sleep, dreams and death, but also here a reference to laudanum. Directly behind, an illuminated sundial, showing 9 o'clock, the hour of Beatrice's death, reminds us of the passage of time and of the loss that goes with it. Beatrice herself is dressed in a green tunic over a dress of purple-grey – 'the colours of hope and sorrow as well as of life and death'.[1] Behind her, against a distant background of medieval Florence, Dante looks across the empty, charged townscape to an orange-clad figure on the left. This angelic vision of Love holds in his hand a flickering flame around a heart, which represents the gradual waning of Beatrice's life and temporal love.

The supremely heightened and sacred moment, held for ever, accords with Rossetti's belief in the sacramental nature of sexual love and its links with death. Its message could hardly be more different from the fleshly female portraits exemplified by *The Blue Bower* (cat. 8), which form the mainstream of his work in the 1860s. These differences are reflected in its hazy, unfocused quality, which emphasizes the transcendental character of the image and may be connected with opium-inspired visions. Alternatively, they may reflect Rossetti's admiration for the 'soft focus' photographs of Julia Margaret Cameron or his interest in spiritualism.

Rossetti designed the frame of both the original and this version himself, incorporating further references to Dante.

1. F. G. Stephens, '*Beata Beatrix* by Dante G. Rossetti', *The Portfolio*, XXII, 1891, p. 46.

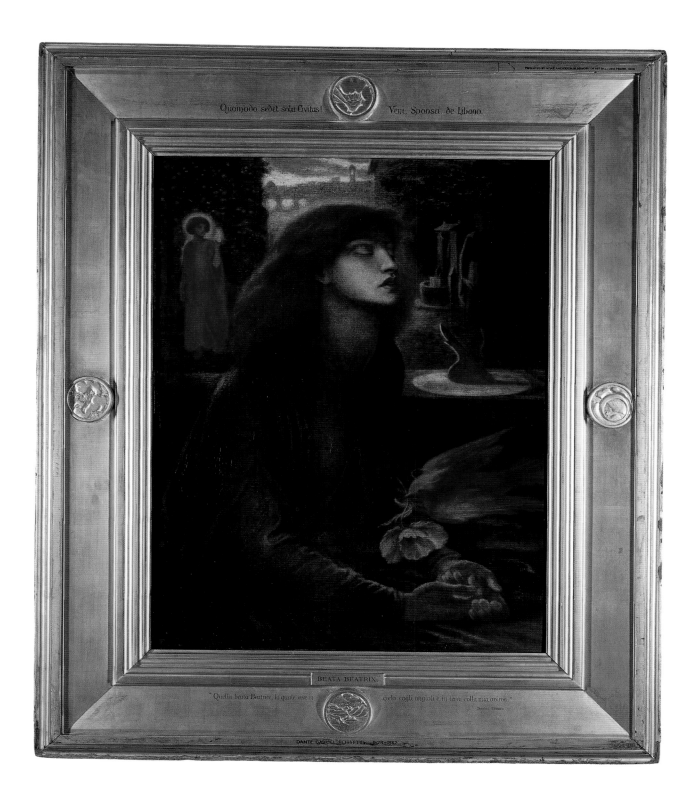

49

8 *The Blue Bower*, 1865

Oil on canvas, 84 × 70.9 cm (33 × 28 in)
Signed in monogram and dated lower right: DGR 1865
The Barber Institute of Fine Arts, The University of Birmingham

Begun in April 1865, this is Rossetti's central painting of the decade, a masterpiece of his entire career and one of the most sumptuous of all Pre-Raphaelite portraits. The sitter was Fanny Cornforth, his favourite model from about 1858. She later became his mistress and latterly his housekeeper. She is dressed in a fur-lined green robe, unfastened at the front, the loose fit aptly suggesting loose living. Describing the work in 1865, F. G. Stephens noted 'the marvellous fleshiness of the flesh; the fascinating sensuousness of the expression'.[1] This impression is reinforced by her alluring pose, designed to emphasize her flowing auburn hair and magnificent long neck. Before her lies a Japanese *koto*, which she absent-mindedly fingers, hinting perhaps at an absent lover. The lavishness of her costume and jewellery is echoed by the resonant background of tiles, their hexagonal shape and borders indicating an Arab inspiration, while the prunus blossoms are Oriental, probably Chinese. To left and right are passion flowers and wild convolvulus blossoms – symbolic references to the demanding, physical character of the sitter, whose brazenness is also reflected in the loud and colourful necklet, hairpin and earring (see cat. 44). In the foreground is a posy of cornflowers, punning on her name.

While taking its title from contemporary literature, *The Blue Bower* owes much to sixteenth-century Venetian portraits of courtesans by Titian and his circle, in whom Rossetti was much interested in the early 1860s (cat. 14). It outshines such works, however, in its overall sensuousness, colour harmonies and rich, decorative patterns. Evidently intended as an object of beauty in its own right and lacking any narrative content, the picture is an early instance of 'art for art's sake', anticipating the ideas of the Aesthetic Movement. It is a highly significant prototype for visionary female portraits by Albert Moore, Frederick Sandys and others.

Several related drawings are known, including cat. 36 and one in an American private collection showing the sitter holding an upright stringed instrument (fig. 4). The painting is in an English gilded frame in the Italian Renaissance style. It is almost certainly original to the picture.

1. *The Athenaeum*, no. 1982, 21 October 1865, p. 546.

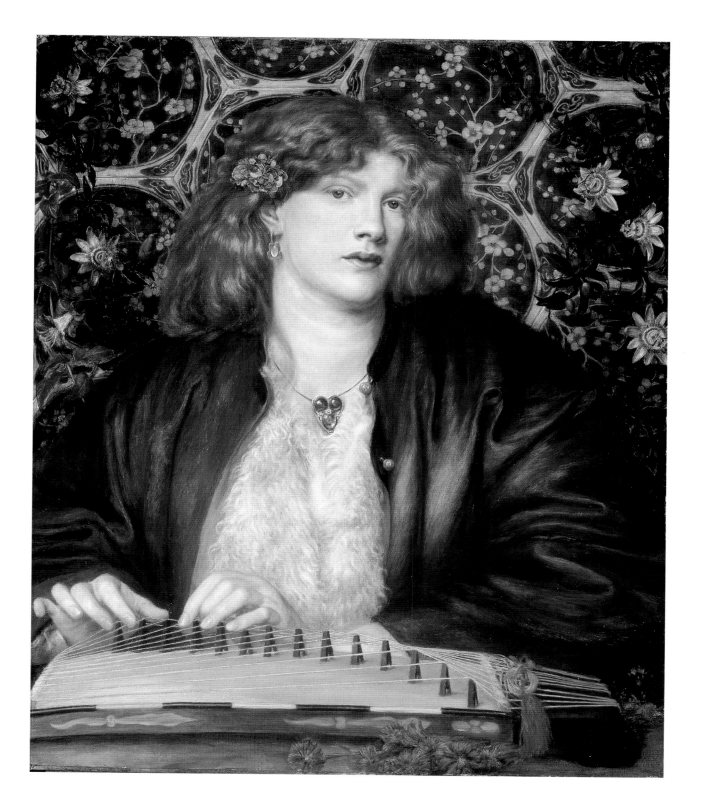

9 *Monna Vanna*, 1866

Oil on canvas, 88.9 × 86.4 cm (35 × 34 in)
Signed in monogram and dated lower left: DGR 1866
Tate Britain, London

The sumptuous pictures painted in celebration of female beauty in the middle years of the decade reached a climax with *Monna Vanna*. Rossetti was working on it in August 1866.[1] The model was Alexa Wilding, whom he had first used in the spring of 1865. In his mind the work had Venetian qualities and his original title reflected this. 'It is called "Venus Veneta",' he wrote, 'and represents a Venetian lady in a rich dress of white and gold, – in short the Venetian ideal of female beauty.'[2] *Monna Vanna* was the second title, chosen after completion of the painting. It derives from Dante's *Vita Nuova* but also occurs in Boccaccio. It was changed again to *Belcolore* in 1873, when Rossetti retouched parts of the painting at Kelmscott Manor. This third title seemed to him more in keeping with 'so comparatively modern-looking a picture', but the second title is used today.

The spiralling composition is extremely striking and emphasizes the copiousness of the great sleeve in the foreground. This certainly recalls Renaissance portraits, such as Palma Vecchio's *Portrait of a Poet* (cat. 13). Evelyn Waugh commented memorably: 'It is all sleeve . . . the great swirl of gold and white, prolonged and accentuated by the folds of the dress stands out from the picture as though at some yards distant from the rest of the body, like the partially deflated envelope of an airship designed by some tipsy maharajah.'[3] The white and gold material was also used by the artist in *Monna Rosa* (location unknown) and other contemporary paintings. The exotic pearl hair clasp was one of his favourite decorative accessories (see fig. 14), as were the crystal heart and the red coral necklace. The latter also appears in Frederick Sandys's *Medea* (cat. 20).

The original frame is in two parts: an outer moulding of reeded black barred with gold, and an inner flat decorated with wavy fronds, known as a 'Venetian' or 'brocade' pattern and used by Ford Madox Brown and G. F. Watts as well as Rossetti. The first owner was the Cheshire collector W. Blackmore, but in 1869 he sold the work to George Rae of Birkenhead, one of Rossetti's most important patrons.

1. Doughty and Wahl, ii, p. 602; letter to Mrs Gabriele Rossetti, 24 August 1866.
2. Doughty and Wahl, ii, p. 606; letter to John Mitchell, 27 September 1866.
3. E. Waugh, *Rossetti: His Life and Works*, London, 1928, p. 138.

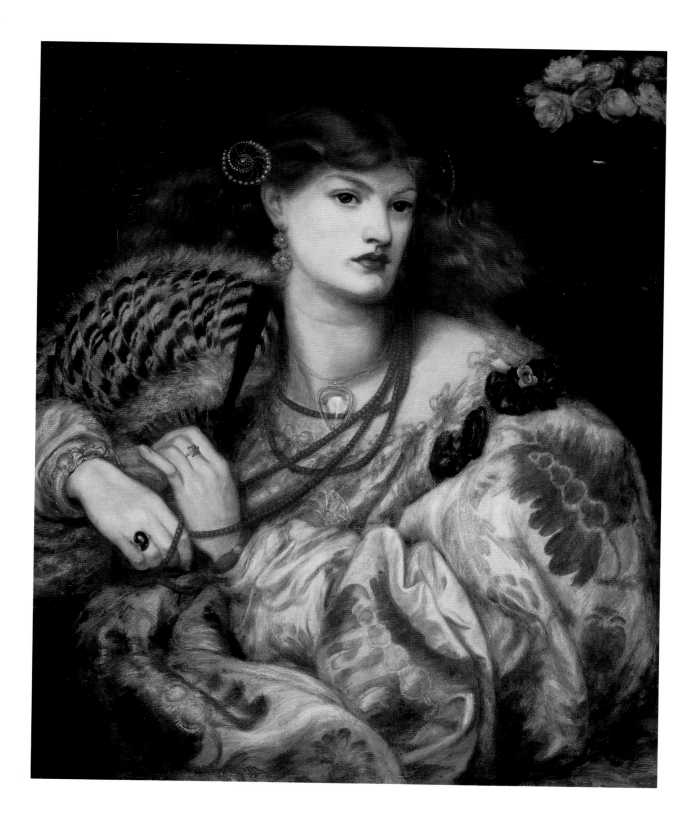

10 *Veronica Veronese, 1872*

Oil on canvas, 107.9 × 86.3 cm (41$^1/_2$ × 34 in)
Signed in monogram and dated lower right: DGR 1872
Delaware Art Museum, Wilmington [CAI]

Veronica Veronese is a more passionate development of the musical reverie theme used in *The Blue Bower*. Here the woman has become the 'true icon' for the artistic soul in the act of creation.[1] The French inscription on the frame, ascribed to 'Girolamo Ridolfi', is likely in fact to have been composed by Rossetti or Swinburne. It may be translated as:

> Suddenly leaning forward, the Lady Veronica rapidly wrote the first notes on the virgin page. Then she took the bow of the violin to make her dream reality; but before commencing to play the instrument suspended from her hand, she paused for a few moments, listening to the inspiring bird, while her left hand strayed over the strings searching for the supreme melody, still elusive. It was the marriage of the voices of nature and of the soul – the dawn of a mystic creation.

Rossetti's symbolism is particularly esoteric in this work but it has recently been shown that he used Cesare Ripa's *Iconologia* as a primary source for the picture.[2] The daffodils refer to the woman's narcissistic or reflective state of mind, but they are also likely to have been included for their striking colour, since Rossetti spoke of *Veronica Veronese* as 'a study of varied greens'.[3] As the picture was finished in February, a month symbolized by primroses, their inclusion may be a private statement by the artist. The canary is easier to interpret, as in Christian symbolism an uncaged bird represents the unfettered soul.

The model was Alexa Wilding, whose neck and fingers Rossetti has exaggerated even more than usual, reflecting a new interest in Michelangelo and Florentine Mannerism. Her three-quarter-length figure exemplifies a trend away from bust-lengths, which began with *Lady Lilith* (cat. 6) and intensified at the end of the decade. The work was painted for F. R. Leyland, himself an amateur violinist.

1. M. W. Ainsworth *et al.*, *Dante Gabriel Rossetti and the Double Work of Art*, New Haven, Yale University Art Gallery, 1976, p. 97.
2. S. P. Smith in *Pre-Raphaelite Art in its European Context*, eds. S. P. Casteras and A. C. Faxon, Cranbury, NJ, 1995, pp. 56–8.
3. Letter to F. R. Leyland, 25 January 1872, *Art Journal*, 1892, p. 250.

11 *La Ghirlandata*, 1873

Oil on canvas, 115.6 × 87.6 cm (45$^1/_2$ × 34$^1/_2$ in)
Signed and dated lower right: D.G. Rossetti 1873
Guildhall Art Gallery, Corporation of London [BI]

Like *Veronica Veronese* (cat. 10), *La Ghirlandata* is a compositional development of *The Blue Bower* (cat. 8). One of the preliminary drawings for that work showed the model with an upright stringed instrument and may well have suggested the present arrangement to the artist (fig. 4). Between 1871 and 1874 Rossetti elaborated the formula in a group of decorative paintings featuring women playing musical instruments, which he offered to Frederick Leyland. These included *La Ghirlandata*, *Veronica Veronese* and *The Bower Meadow* (fig. 17). but Leyland bought only *Veronica Veronese* together with *The Roman Widow* (Museo de Arte de Ponce, Puerto Rico), leaving Rossetti to sell the present work to another loyal patron, William Graham.

La Ghirlandata ('The Garlanded Lady') was painted in the summer of 1873 at Kelmscott Manor, with Alexa Wilding as the model and May, younger daughter of William and Jane Morris, sitting for the heads of the watching angels. Rossetti described it as 'the greenest picture in the world . . . the principal figure being draped in green and completely surrounded with glowing green foliage'.[1] The subject is elusive and the title derives from the prominent garland of roses and honeysuckle hanging from the harp. Both flowers, but particularly honeysuckle, suggested sexual attraction to Rossetti, who had already used them to this effect in *Venus Verticordia* (cat. 5). It has been noted that, as with all his late works, a sense of still enchantment is combined with one of burgeoning change, controlled by a beautiful woman.[2] The blue wings on the harp are symbolic of the flight of time, but according to William Michael Rossetti the picture had a more sinister general meaning. 'It must be intended to have a fateful or deadly purport,' he wrote, 'as indicated by the prominence given to the blue flowers of the poisonous monkshood. Monkshood this plant was in Rossetti's intention; but I am informed that he made a mistake (being assuredly far the reverse of a botanist), and figured the innocuous larkspur instead.'[3]

Among Rossetti's significant compositional innovations are the use of a landscape setting and of multiple figures. The work retains its original frame.

1. R. Glynn Grylls, *Portrait of Rossetti*, London, 1964, p. 157.
2. A. Grieve, *The Pre-Raphaelites*, Tate Gallery, London, 1984, p. 223.
3. W. M. Rossetti, *Art Journal*, 1884, p. 206.

12 *Proserpine*, 1882

Oil on canvas, 119.5 × 57.8 cm (47 × 22³/₄ in)
Inscribed on scroll bottom left: DANTE GABRIELE ROSSETTI. 1882; and at
 upper right with Rossetti's sonnet on the subject
Birmingham Museums and Art Gallery

During the last decade of his life Rossetti began no fewer than eight versions of *Proserpine*, of which this is the last (see also fig. 13). All display the features of Jane Morris, with whom he had established an intimate relationship by July 1869 and remained obsessively in love until his death. According to legend, Proserpine divided her time between the underworld, where she was held in thrall by Pluto, and earth, where spring returned at her arrival. Parallels therefore existed with Jane Morris's own situation, married to another man and unattainable to Rossetti. He explained the subject in the following terms:

> The figure represents Proserpine as Empress of Hades. After she was conveyed by Pluto to his realm, and became his bride, her mother Ceres importuned Jupiter for her return to earth, and he was prevailed on to consent to this, provided only she had not partaken of any of the fruits of Hades. It was found, however, that she had eaten the grain of a pomegranate, and this enchained her to her new empire and destiny. She is represented in a gloomy corridor of her palace, with the fatal fruit in her hand. As she passes, a gleam strikes on the wall behind her from some inlet suddenly opened, and admitting for a moment the light of the upper world: and she glances furtively towards it, immersed in thought.[1]

Proserpine's full red lips, flowing hair, intense gaze and dark green costume create a mood of oppressive sensuality, comparable with but infinitely more foreboding than the earlier pictures of Fanny Cornforth. In contrast to the Venetian prototypes of these works of the 1860s, the tall, narrow format of *Proserpine*, the position and scale of the figure within it and its linear style relate more to the Florentine Renaissance and may have been suggested by Botticelli's *Portrait of Smeralda Brandini* (Victoria and Albert Museum), which Rossetti bought in 1867.

1. W. Sharp, *Dante Gabriel Rossetti: A Record and Study*, London, 1882, p. 236.

13 Jacopo Palma il Vecchio (1479/80?–1528)
Portrait of a Poet (Ariosto?), c. 1516

Oil on canvas, 83.8 × 63.5 cm (33 × 25 in)
The National Gallery, London [BI]

Rossetti's interest in the painters of the Venetian Renaissance originated in the 1850s, but intensified about 1860, reflecting the recent acquisition of Venetian works at the National Gallery. In 1857 Veronese's sublime *Family of Darius before Alexander* was bought, a coup that was followed in 1860 by the acquisition of the Beaucousin collection, among which was the present painting. The sitter was then believed to be the celebrated Ferrarese poet Lodovico Ariosto (1474–1533) – a subject likely to have had a strong fascination for Rossetti, whose *Early Italian Poets* was published in 1861.

Palma's assured portraits are derived from Giovanni Bellini, Giorgione and, most of all, Titian. Here his brilliant execution of the sitter's costume finds a counterpart in *Monna Vanna* (cat. 9), while his use of patterned background in the form of the laurel, traditionally associated with poets, is echoed by Rossetti's decorative and symbolic backgrounds in *Bocca Baciata* and later works (cat. 1). In stressing the two-dimensionality of the pictorial surface, often reducing his figures to elements in the design, Rossetti may be seen as a forerunner of Modernism and Venetian art as a catalyst in this process, which further distanced Rossetti from Victorian narrative painting.

14 Jacopo Palma il Vecchio
Portrait of a Young Lady ('A Sibyl'), c. 1522–4

Oil on wood, 72 × 54.5 cm (28³/₈ × 21¹/₂ in)
Derek Johns Ltd, London

Palma Vecchio studied under Giovanni Bellini in Venice, where, apart from a short time spent in Bergamo, he remained until his death. One of his specialities was half-length portraits of courtesans or young beauties, in which he continued a well-established Venetian tradition. The present picture is one of two versions, the other being in the Royal Collection at Hampton Court. The blonde model, standing before a darkened niche, strongly resembles the girl in *'Flora'* (National Gallery, London) and the picture can probably be dated to the same period, 1522–4. Rossetti's interest in the Venetian School is well documented and several of his ideal female portraits of the 1860s are close to this work. This is especially true of *The Blue Bower*, where the most obvious points of similarity are the model's amplitude of form, abundance of fair hair, and *déshabillé* dress. In the foreground of each is an exotic object – a table with cabbalistic lettering in the present case, which, like the Japanese *koto* in *The Blue Bower*, provides a mysterious foil for an all-too-earthy model, hinting at her power to enchant. It is not known whether Rossetti was aware of this picture as its location is unrecorded in the 1860s, although it was in an English collection at the beginning of the nineteenth century. However, he almost certainly saw the version in the Royal Collection, which had been at Hampton Court since 1833. The palace was a favourite haunt of his circle and a number of visits are recorded, including one by Rossetti and G. P. Boyce in 1865, when the painters had a '2 hours spell' at the pictures, which included a high proportion of Venetian works.[1]

1. V. Surtees (ed.), *The Diaries of George Price Boyce*, Norwich, 1980, p. 43.

63

15 Frederic Leighton (1830–96)
A Roman Lady, 1859

Oil on canvas, 80 × 52 cm (31 × 20 in)
Philadelphia Museum of Art

Leighton grew up in Germany and Italy, receiving an entirely continental art education, notably in Frankfurt under the Austrian Nazarene, Eduard von Steinle (1810–86). In 1859 he decided to settle permanently in England, where he was already a respected artist following the purchase of *Cimabue's Madonna* by Queen Victoria four years earlier. *A Roman Lady* was one of at least four idealized portraits painted in Rome of the professional model Anna Risi. Three of them were exhibited at the Royal Academy to mark his return and they are known to have affected Rossetti deeply. 'Nanna' was renowned for her statuesque beauty and melancholy temperament – both brilliantly conveyed here in her condescending demeanour. Leighton intended the pictures as complementary, anticipating Rossetti's serial portraits of Elizabeth Siddal, Fanny Cornforth and Jane Morris. Their conscious sexual power was noted by F. G. Stephens, who believed the sitter 'might be a Vittoria Corombona,[1] so feeling and passionate she looks.' In *Pavonia* (Private Collection), another in the series, where Nanna preens herself before a great fan of peacock feathers, he particularly admired her 'backward, yet proud look . . . worthy of a Lucrezia Borgia'.[2]

A Roman Lady reflects Leighton's admiration for paintings of the Italian Renaissance, with marked overtones of Pontormo and Leonardo, and mannerist grotesques decorating the pilaster before which she stands.[3] However, the lush, scumbled colours and luxurious fabrics of her extravagant Italian costume recall nothing so much as Titian and Veronese, prefiguring Rossetti's *Blue Bower* and *Monna Vanna* (cats. 8 and 9). Yet Leighton's picture is more restrained than either of those works, which lack the contrast between Nanna's smouldering looks and her dispassionate interest in them. Nanna's lover, the German artist Anselm Feuerbach, produced a major series of portraits of her, including one in 1866 as Lucrezia Borgia (Städelsches Kunstinstitut, Frankfurt) and one as a mandolin player (fig. 18).

1. The tragic Venetian heroine in John Webster's *The White Devil* (1612).
2. *The Athenaeum*, no. 1645, 7 May 1859, p. 618.
3. R. G. Dorment, '*A Roman Lady* by Frederic Leighton', *Bulletin of the Philadelphia Museum of Art*, LXXIII, June 1977, p. 5.

16 Frederic Leighton
Lieder ohne Worte, 1860–1

Oil on canvas, 101.6 × 62.9 cm (40 × 25 in)
Tate Britain, London [BI]

Started soon after his return to London in 1859, *Lieder ohne Worte* was shown at the Royal Academy exhibition of 1861, when Leighton wrote, 'I have endeavoured, both by colour and by flowing, delicate forms, to translate to the eye of the spectator something of the pleasure which the child receives through her ears.'[1] The evocative title, suggested by a visitor to Leighton's studio, is identical to that of Mendelssohn's piano pieces of 1829–45, in which song was paradoxically created without the human voice. Here the phrase may imply more than its literal meaning – perhaps something like reverie. Leighton's concern with the nature of artistic interpretation and the picture's lack of narrative link it with Rossetti's musical paintings such as *Veronica Veronese* (cat. 10). He seems to have intended the tonal harmony as an equivalent to the aural harmony of the blackbird's song and plashing water. His architectural setting is fanciful and highly eclectic. One critic described it as 'a palace of no date – it may be Roman in the luxurious days; it may be Pompeian; it may be Egyptian of Cleopatra's age; it may even be Palladian of the best time of the Renaissance. . .'[2] The frame, designed by Leighton himself, carries on the intricate architectural effect with circular and interlinked patterns like those on the vases and the floor. Its overall hard-edged quality contrasts markedly with the girl's relaxed attitude and her swirling costume. Sexual ambiguity is rife in the work, for the decidedly feminine, if pre-pubescent, slave was actually based on a drawing of 'Johnnie' Hanson Walker, a male protégé of Leighton's. Recent interpretations of the picture have suggested homo-erotic meanings and certainly the androgynous being brings to mind epicene figures by Rossetti's homosexual follower, Simeon Solomon (fig. 16). When Rossetti saw *Lieder ohne Worte* at the Royal Academy he described it as 'the only good one' (of Leighton's submissions) and sympathized with the 'striking unfairness' of the way it was hung.[3]

1. Mrs R. Barrington, *The Life, Letters and Work of Frederic Leighton*, II, 1906, p. 63; letter to Eduard von Steinle, 30 April 1861.
2. *The Athenaeum*, no. 1749, 4 May 1861, pp. 600–1.
3. Doughty and Wahl, II, p. 399.

17 Gustave Courbet (1819–1877)
Jo, The Beautiful Irish Girl, 1865–6

Oil on canvas, 54 × 65 cm (21$^1/_4$ × 25$^1/_2$ in)
Signed and dated lower left: 66 Gustave Courbet
Nationalmuseum, Stockholm

Painted in the same year as *The Blue Bower*, this work provides a fascinating link between Rossetti's iconic and voluptuous beauties and contemporary French painting. Courbet's isolated subject, framed by superabundant tresses of Titian-red hair and absorbed in self-regard, is particularly close to *Fazio's Mistress* (fig. 3), *Lady Lilith* (cat. 6) and *Woman combing her Hair* (cat. 33). Her rich garment with copious sleeves, hinting at sixteenth-century Venice, also parallels *The Blue Bower*, while the flat background forces the figure to the front of the picture plane, creating an enclosed, claustrophobic space. Courbet's model was Joanna Hiffernan, the Irish mistress of Whistler, who also appears in his *Symphony in White, No. III* (cat. 19). Courbet began his painting in the summer of 1865, when he was working with Whistler at Trouville. He wrote enthusiastically of Jo to his friend and patron Alfred Bruyas: 'Among the two thousand ladies who have come to my studio . . . I admired the beauty of a superb redhead whose portrait I have begun.'[1]

He went on to execute three other versions of the painting, and to include Jo, who later became his mistress, in his major commissioned work of 1866, *The Sleepers* (Musée du Petit Palais, Paris). This was in turn influenced by Rossetti's *Golden Head by Golden Head*, designed as a frontispiece for his sister Christina's poem *Goblin Market*, published in 1862. Courbet probably knew this through Whistler, who became a friend of Rossetti in 1863. Rossetti's own assessment of Courbet was less than enthusiastic. After a visit to his studio in November 1864 (in Courbet's absence) he wrote: 'I saw various works of his – by far the best an early portrait of himself about 23 or 24, resting his head on his hand. It is rather hard and colourless, but has many of the fine qualities of a Leonardo. His other works have great merit in parts and are all most faulty [sic].'[2] In general, his opinion of the French school was derogatory: 'It is well worth while for English painters to try and do something new, as the new French school is simple putrescence and decomposition.'[3]

1. P. Borel (ed.), *Lettres de Gustave Courbet à Alfred Bruyas*, Geneva, 1951, p. 116.
2. Doughty and Wahl, II, p. 526; letter to William Michael Rossetti, 8 November 1864.
3. Doughty and Wahl, II, p. 527; letter to his mother, 12 November 1864.

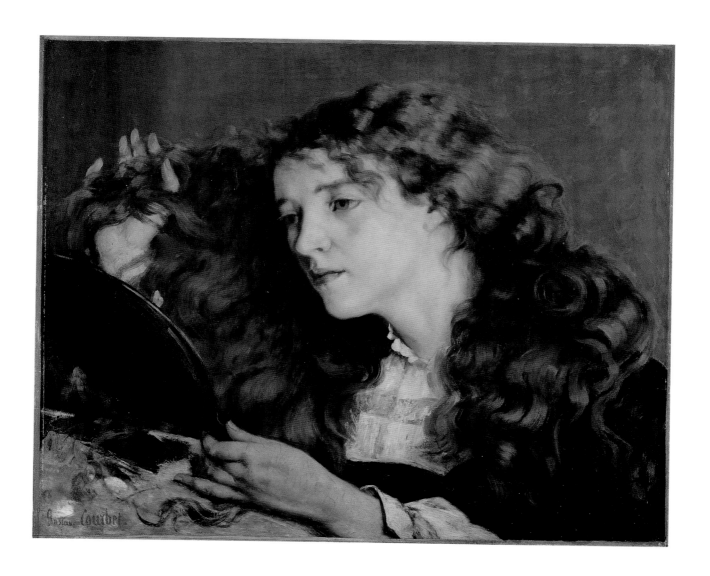

18 James McNeill Whistler (1834–1903)
Purple and Rose: The Lange Leizen of the Six Marks, 1864

Oil on canvas, 92 × 61.5 cm ($36^{1}/_{4}$ × $24^{1}/_{4}$ in)
Signed and dated upper right: Whistler 1864
Philadelphia Museum of Art [CAI]

Whistler received much of his artistic training in Paris, where he befriended Alphonse Legros, Fantin-Latour, Tissot, Courbet and Manet and became a devotee of the new cult of Japan and the Far East. On moving to Chelsea in 1863 he associated closely with Rossetti, who took up his enthusiasm for Oriental porcelain, collected it avidly and used it in *The Blue Bower* and other pictures (cats. 8 and 33). Whistler's mother tellingly described their enthusiasm in a letter to an American friend:

> Are you interested in old china? This artistic abode of my son is ornamented by a very rare collection of Japanese and Chinese. He considers the paintings upon them the finest specimens of art, and his companions (artists), who resort here for an evening's relaxation occasionally get enthusiastic as they handle and examine the curious figures portrayed.[1]

In the present work a European model is shown posing in an artist's studio, dressed in Chinese robes. She is supposedly painting a porcelain vase and is surrounded by other pieces, already finished. Any of these objects could appear in a contemporary work by Rossetti and in 1865 he used a gorgeous Japanese kimono prominently, though incorrectly, in *The Beloved* (fig. 8). The title, while indicating Whistler's interest in abstract colour harmony, refers to the decorative figures forming the maker's marks that appear on rare specimens of Chinese blue-and-white porcelain. 'Lange Leizen' is Dutch slang for 'Long Elizas'. The six Chinese characters around the frame are copied from the bottom of a piece of blue-and-white porcelain and mean: 'Made during the reign of the Emperor K'ang Hsi, of the great Ch'ing dynasty.' However, despite this archaeological exactness *Purple and Rose* remains in essence a Victorian genre scene, lent a superficial exoticism by Oriental objects.

1. K. Abbott (ed.), 'A. McNeill Whistler, "The Lady of the Portrait, Letters of Whistler's Mother"', *Atlantic Monthly*, CXXXVI, 1925, pp. 323–4. Cited in R. Dorment and M. Macdonald, *James McNeill Whistler*, Tate Gallery, London, 1994, p. 86.

19 James McNeill Whistler
Symphony in White, No. III, 1865–7

Oil on canvas, 51.4 × 76.9 cm (20 × 30$^1/_8$ in)
Inscribed, signed and dated lower left: Symphony in White, No. III. –
 Whistler. 1867 – [the figure 7 written over a 5]
The Barber Institute of Fine Arts, The University of Birmingham [BI]

Whistler had begun work on this by August 1865, having known Rossetti for
three years. During that period he had painted several Oriental pictures featuring
'stunners' posed in exotic settings in colourful embroidered kimonos, with
Japanese screens, fans and pots (cat. 18). In 1865, however, he met Albert Moore,
under whose influence he began to merge classical elements with Japanese (see
cat. 21). In the present work a frieze-like composition is punctuated by a Japanese
fan, irises, chrysanthemums and azaleas. More important is Whistler's clear
understanding of the underlying principles of Japanese design – its flatness, its
boldness of placing and outline, and the subordination of detail to overall effect.

Symphony in White, No. III was not completed until 1867, when it was exhibited
at the Royal Academy. The models were Milly Jones (seated on the floor) and
Joanna Hiffernan, Whistler's Irish mistress (see also cat. 17). The work was the
first to be given a musical title, chosen by Whistler to emphasize that its beauty
was in no way dependent upon narrative content but was instead absolute, timeless,
and achieved by modulation of tone and hue. This innovation led to a celebrated
controversy with P. G. Hamerton, critic of *The Saturday Review*, which became a
benchmark justification of Aesthetic art. Hamerton complained that it was 'not
precisely a symphony in white. One lady has a yellowish dress and brown hair
and a bit of blue ribbon, the other has a red fan, and there are flowers and green
leaves. There is a girl in white on a white sofa, but even this girl has reddish hair;
and of course there is the flesh-colour of the complexions.'[1] Whistler rejoined
caustically, 'Bon Dieu! Did this wise person expect white hair and chalked faces?
And does he then, in his astounding consequence, believe that a symphony in F
contains no other note, but shall be a continued repetition of F, F, F? . . . Fool!'[2]

Like Rossetti, Whistler paid much attention to the frames of his paintings. Here
the original decoration of Maltese crosses, just discernible beneath later gilding,
repeated the decorations on the rug, combining them with his butterfly monogram.

1. *The Saturday Review*, XXIII, 1 June 1867, p. 691.
2. Quoted by W. Dowdeswell in *The Art Journal*, 1887, p. 101. The comment was probably
 written later than 1867 – see further A. McLaren Young, M. MacDonald, R. Spencer and
 H. Miles, *The Paintings of James McNeill Whistler*, Yale, 1980, p. 34.

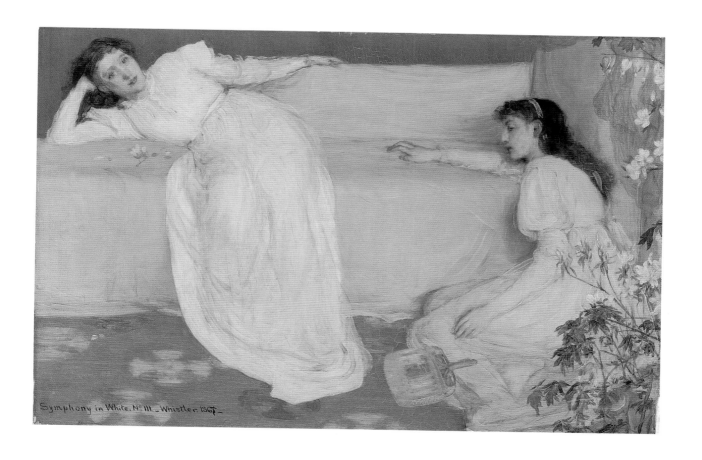

20 Frederick Sandys (1829–1904)
Medea, 1866–68

Oil on wood, 62.2 × 46.3 cm (24$^1/_2$ × 18$^1/_4$ in)
Birmingham Museums and Art Gallery

Sandys first met Rossetti in 1857, but the two became close in the early 1860s and when he painted this work Sandys was sharing Rossetti's house at Cheyne Walk. Heavily influenced by his mentor's sublimely evil *Lilith* (cat. 6) and confrontional *Regina Cordium* (fig. 11), he submitted this glittering piece of decadence to the Royal Academy exhibition of 1868. As in Euripides' play, *Medea*, the discarded wife of Jason, is characterized as a cruel sorceress, preparing a poisoned robe for Glauce, the woman who has supplanted her in his affections. To an educated audience raised on classical myths, the knowledge that she was also to murder her own sons by Jason would have greatly compounded her wickedness. Separated from her viewers by the ledge bearing the eldritch ingredients of her spell – including a pair of copulating toads and a statuette of the Egyptian goddess Sakhmet – she claws distractedly at her coral necklace. As a standard property of Rossetti, appearing in *Monna Vanna* of the same year (cat. 9), the necklace was later taken by him to prove Sandys's plagiarism, which led to a break in their friendship.

The golden screen-like wall behind Medea is alive with Japanese flying cranes and other Oriental motifs, linking this work with Japanese tendencies in Albert Moore (cat. 21) and Whistler (cats. 18 and 19). Jason's ship is shown to the left and the Golden Fleece hangs in the sacred grove to the right, while the fierce talons of the writhing dragon echo Medea's own clenched fingers. As his model, Sandys used his gypsy mistress, Keomi, who also appears in Rossetti's *The Beloved* (fig. 8). He thus went to considerable lengths to stress her exotic and uncivilized aspect, with gaudy jewellery and a sea-shell headdress. The Egyptian figurine may also refer to her gypsy origins.

Although *Medea* was accepted by the Academy, it was not hung until the following year, but Swinburne meanwhile gave this unforgettable account of its sinister subject:

> Pale as from poison, with the blood drawn back from her very lips, agonized in face and limbs with the labour and the fierce contention of old love with new, of a daughter's love with a bride's, the fatal figure of Medea pauses a little on the funereal verge of the wood of death . . . [1]

1. Academy Notes, p. 44.

21 Albert Joseph Moore (1841–93)
A Musician, 1867

Oil on canvas, 28.6 × 38.7 cm (11^1/$_4$ × 15^1/$_4$ in)
Inscribed upper left with Greek anthemion
Yale Center for British Art, New Haven

A Musician was exhibited at the Royal Academy in 1867, the same year as Whistler's *Symphony in White, No. III*, to which it is closely related (cat. 19). Similarities include the frieze-like composition and the enthusiasm for Japanese details such as the encroaching branches on the right, azaleas and irises, and the fans on the dado.[1] The luminous colour schemes that appear in Moore's work at this time were understood by contemporaries as references to the delicate tones of Japanese screens or prints. However, it is Moore's study of ancient sculpture that is most obviously reflected here – the heads are clearly based on antique prototypes, while the musician's pose recalls the seated gods of the Parthenon frieze, which Moore studied in the British Museum. A firmer link with Rossetti's contemporary work is the prominence of the lyre and the implied analogy between the arts of painting and music. This was becoming a favourite tenet of proponents of the Aesthetic Movement, such as Pater and Swinburne, who stressed that the message of a picture, like music, was its sensuous delight. Indeed, Pater went so far as to declare that composer and artist each used their particular type of harmony to transcend intellect and create 'a country of the pure reason or half-imaginative memory.'[2] F. G. Stephens perceptively characterized Moore's paintings as 'a sort of pictorial music drawn as from a lyre of but few strings'.[3] In 1868 Moore exhibited *A Quartet, a Painter's Tribute to the Art of Music, A.D. 1868*, but pioneering as his musical subjects were, precedents may be found for them among Rossetti's watercolours of the 1850s, such as *The Blue Closet* (cat. 28). Leighton also treated musical themes in the early 1860s (see cat. 16).

1. The two listening girls are also close to Whistler's original drawing for *Symphony in White, No. III*, at the Munson-Williams-Proctor Institute, Utica, NY.
2. 'The School of Giorgione' in *The Renaissance, Studies in Art and Poetry*, London, 1922, p. 137.
3. 'Mr Humphrey Roberts's Collection', *Magazine of Art*, XIX, 1896, p. 47.

22 George Frederic Watts (1817–1904)
Study with the Peacock's Feathers, c. 1862–5

Oil on wood, 66 × 56 cm (26 × 22 in)
Signed lower left: G. F. Watts.
Pre-Raphaelite Inc., by courtesy of Julian Hartnoll

Watts became increasingly preoccupied with the Venetian Renaissance following his first visit to the city in 1853. Venetian colour remained a constant influence in his painting after that date, mingled with Michelangelo and the Parthenon marbles (see cat. 23). The luxurious tones and dazzling flesh of the present study provide a telling comparison with Rossetti's rare nude, *Venus Verticordia*, which is also set among flowers and decorative accessories (cat. 5). Both are descended from *Bocca Baciata* (cat. 1), not least in their remoteness of gaze and languor of pose. But Watts's picture is simultaneously more informal and more Venetian, with strong overtones of Veronese in the rendering of flesh, hair, amber and pearls. It also seems to reflect a knowledge of Leighton's decorative studies of Anna Risi (cat. 15), one of which, *Pavonia* (Private Collection), prominently featured peacock feathers as a backdrop. Soon afterwards peacock plumes became a symbol of the Aesthetic Movement. Although *Study with the Peacock's Feathers* was probably executed in 1862, it was not exhibited until 1865, when it appeared at the French Gallery. No doubt Watts did not want to show something experimental in type and broad in technique at the more public Royal Academy – just as Rossetti refused to show his unconventional visions of beauty there. Nevertheless, in the years immediately following, Watts, together with Leighton and Albert Moore, contributed major nudes to the Royal Academy, helping to re-establish the genre, which had almost disappeared in Britain since the death of William Etty, its main exponent, in 1849.

23 George Frederic Watts
The Wife of Pygmalion, 1868

Oil on canvas, 66 × 55.3 cm (26 × 21³/₄ in)
The Faringdon Collection Trust, Buscot Park [BI]

Although Watts was one of the last grand allegorical painters of the nineteenth century, his high-minded search for abstract beauty ranged him with Rossetti and Whistler as a rebel against narrative art. This classical subject links Victorian High Art, expressed in idealized form, with the beginnings of Aestheticism, current in England from the early 1860s. *The Wife of Pygmalion* makes a particularly telling comparison with *Venus Verticordia* (cat. 5) in format and technique, and in the prominent abstract qualities of both works. A bust-length nude is set against a decorative, floral background, yet Watts deliberately restrains his colours and stresses the opacity of his paint, allowing highlights to emerge only occasionally. Her stony appearance and drapery derive largely from Greek prototypes, including the Parthenon marbles, which were restored and redisplayed in 1865 in the British Museum. In particular, Watts based the image on a cast taken from the Arundel Marbles at the Ashmolean Museum, Oxford, which he believed to represent Aspasia, the celebrated courtesan and companion of Pericles. According to legend, the ancient sculptor Pygmalion created a statue of a woman so beautiful that he fell in love with it and successfully besought Venus, goddess of Love, to bring it to life as Galatea. It is this very moment that Watts depicts, as blood begins to infuse the lips and nipple, while movement is suggested by irregular grouping of the lilies and orchids. Galatea's eyes, however, remain opaque and her hair is tightly confined, making her the very antithesis of Rossetti's sinuous, enticing beauties.

The picture was seen by Swinburne as an example of synaesthesia, approximating the work of sculptor and painter, and he defined it as the 'translation of a Greek statue into an English picture'.[1] The subject was taken up by William Morris, inspired by whose poem *The Earthly Paradise* (1868–70) Burne-Jones painted his famous series *Pygmalion and the Image* (Birmingham Museums and Art Gallery).

1. Academy Notes, p. 31.

24 George Frederic Watts
Portrait of Dante Gabriel Rossetti, c. 1871

Oil on canvas, 64.8 × 51.4 cm (25 × 20 in)
Signed lower right: G. F. Watts
National Portrait Gallery, London

Watts was renowned for his portraits despite his own wish to be remembered as a painter of history and allegory. He first met the young Rossetti among the Kensington circle of Henry and Sara Prinsep at Little Holland House, which also included Tennyson, the photographer Julia Margaret Cameron and the other young Pre-Raphaelites. During the 1860s his artistic links with Rossetti were close as he became more focused on non-narrative symbolic subjects and increasingly dedicated to Venetian colour (see cat. 22). The present portrait was executed around 1871, when Rossetti was about 43. By this time he had serious health problems and was already showing signs of premature ageing, as can be confirmed by comparing this portrait with Lewis Carroll's photograph of 1863 (cat. 40). His hair is receding and his face careworn, yet the portrait does give him something of the accepted appearance of a poet – an image that he was anxious to emphasize at a time when his volume, *Poems*, had just been published. The portrait, engraved by Frederick Hollyer, was used as the frontispiece to H. C. Marillier's landmark biography of Rossetti in 1899.

25 Arnold Böcklin (1827–1901)
The Muse of Anacreon, 1873

Oil on canvas, 79 × 60 cm (31 × 23$^1/_2$ in)
Signed upper right: A.B.
Aargauer Kunsthaus, Aarau [BI]

During the 1860s Böcklin, whose origins were in Basel, based himself in Italy and began to paint loosely-clad half-lengths of idealized classical beauties such as *Sappho* (1862) and *Viola* (1866, both Kunstmuseum, Basel). Modelled on his Italian wife, or in the present instance on his daughter, they provide a European and specifically a Germanic parallel with Rossetti's idealized women, whose luxurious accoutrements and frequently disturbing attitudes they share, despite major differences in the artists' techniques. *The Muse of Anacreon* bears colouristic similarities to *The Blue Bower*, while its poetic theme and leafy outdoor setting are more comparable with the contemporary *La Ghirlandata* (cat. 11). The subject is Euterpe, the muse of lyric poetry, of which the ancient Greek poet Anacreon, famous for his verses on love and wine, was a leading exponent. The intensity of Böcklin's colours, and his evident debt to Italian Renaissance works, strongly echo Rossetti's fascination with the beauties of the Venetian school while the musical iconography and literary title find a direct parallel in *The Blue Bower*. Although Böcklin may not have known Rossetti's work at this time, each expresses a heightened Romantic sensibility and poeticism, prefiguring Symbolist art in Europe.

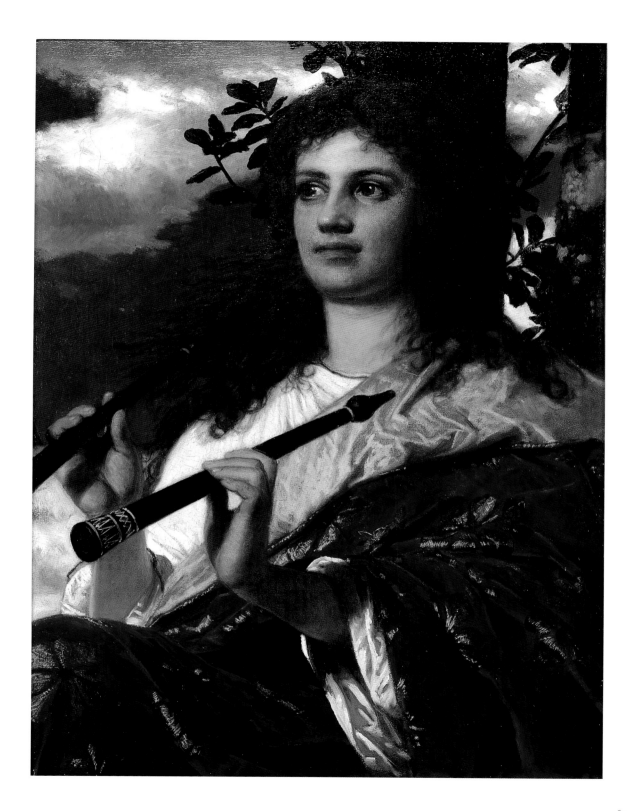

26 Kate Bunce (1858–1927)
Melody (Musica), c. 1895

Oil on canvas, 76.3 × 51 cm (30 × 20$^{1}/_{8}$ in)
Signed in monogram lower left: KB
Birmingham Museums and Art Gallery

Kate Bunce was a student at the Birmingham School of Art in the 1880s and
1890s. *Melody* was conceived under the influence of Rossetti and is
reminiscent of *The Blue Bower* and other works of the 1860s in its musical
subject, claustrophobic composition and opulent setting. It may have been
inspired by the acquisition of one version of *Beata Beatrix* by Birmingham
Museum and Art Gallery in 1891 (see cat. 7), while *Lucrezia Borgia* is recalled
in the positioning of a circular, convex mirror behind the woman's head (cat.
31). Rossetti used such mirrors in a number of his pictures, but this one and
the woman's necklace are of a style associated with the Birmingham School
and may have been made by the artist's sister Myra. Bunce's undistinguished
model is worlds away from the sensual 'stunners' of Rossetti and her striking
mix of textures and surfaces is achieved through solid handling and bright,
enamel-like colours. The religious scene reflected in the mirror and the
angels decorating the wall identify the prevailing mood as one of pious
contemplation, indicating that this player's absorption in her music is
reverent rather than self-gratifying. While *Melody* vividly displays the intensity
of *fin-de-siècle* Pre-Raphaelitism that Bunce helped to elaborate, it could hardly
be more different from Edvard Munch's contemporary *Madonna*, which,
nurtured by European sophistication, marks the ultimate development of the
Rossettian *femme fatale* (cat. 43).

27 *Head of Elizabeth Siddal, 1855*

Pen, brown and black ink with wash, 13 × 11.2 cm (5 × 4³/₈ in)
Signed in monogram and dated lower left: DGR Feb 6. 1855
The Visitors of the Ashmolean Museum, Oxford

Rossetti first met Lizzie Siddal in 1849 and almost immediately she became his muse, representing in life and death his ideal of angelic womanhood. Born in 1829, she was the daughter of a Sheffield cutler. The exact nature of her attraction for Rossetti remains elusive, but aspects of it were certainly 'a sovereign grace, a latent talent and unremitting ill health'.[1] She was said to hold herself 'like a queen', possessing long limbs and neck, with a head framed in straight, loosely fastened hair 'like dazzling copper'. She was, in short, the very paradigm of a Pre-Raphaelite 'stunner'. Here Rossetti shows her features illuminated by gaslight, reflecting the frequent melancholy of her changing moods, her head thrown into relief against the cross-hatching of the background. Recent scholarship has recognized her artistic and poetic talents as something more than a foil for Rossetti's. Several of her own works, in which she was supported by Ruskin, were shown at the Pre-Raphaelite exhibition of 1857 in Russell Place. After a long stormy relationship, Rossetti finally married her on 23 May 1860. Two years later, having given birth to a stillborn child in 1861, she was dead. Distraught and guilt-ridden, Rossetti buried his manuscript poems with her. But in October 1869 he had her grave in Highgate Cemetery opened so as to retrieve them for publication, when, it was reported, the radiant brightness of her red-gold hair retained all the splendour of life. Despite his preoccupation with other women, Rossetti remained deeply attached to her until his own death, writing in 1882: 'As much as in a hundred years she's dead: Yet is today the day on which she died.'

1. V. Surtees, *Rossetti's Portraits of Elizabeth Siddal*, Oxford, 1991, p. 7.

28 *The Blue Closet*, 1856–7

Watercolour, 34.3 × 24.8 cm (13$^1/_2$ × 9$^3/_4$ in)
Signed in monogram and dated lower right: DGR 1857
Tate Britain, London

Described by the artist as 'some people playing music', the subject is enigmatic, but may be Arthurian and related to an illustration of *King Arthur and the Weeping Queens* for Moxon's *Tennyson*, completed at the end of 1856. The two inner women are playing an imaginary musical instrument of challenging complexity. On top of it lie sprigs of holly, suggesting Christmas – presumably the time of year when the work was executed – while the sun and moon were devices often used by Rossetti to suggest the passage of time. Appropriately, in view of its obsessive medievalism, *The Blue Closet* was bought by William Morris, who wrote a poem inspired by it. According to him the red-orange lily in the foreground is connected with death. Rossetti exhibited *The Blue Closet* at the Pre-Raphaelite exhibition in Russell Place in 1857, confirming the high regard in which he held it. In certain aspects it directly anticipates *The Blue Bower* and other musical oils of the 1860s and 1870s, notably in its colour harmonies, tiled background and title. F. G. Stephens was probably paraphrasing Rossetti himself when he defined the watercolour as

> an exercise intended to symbolise the association of colour with music . . .
> The sharp accents of the scarlet and green seem to go with the sound of
> the bell; the softer crimson purple and white accord with the throbbing
> notes of the lute and the clavichord, while the dulcet, flute-like voices of the
> girls appear to agree with those azure tiles on the wall and floor . . .'[1]

1. F. G. Stephens, *Dante Gabriel Rossetti*, London, 1894, pp. 110–11.

29 *The Palace of Art (St Cecilia)*, 1857

Wood engraving, 8.6 × 7.9 cm ($3^3/_8$ × $3^1/_8$ in)
Signed in monogram lower right: DGR; and inscribed: Dalziel
Tate Britain, London

In 1857 Edward Moxon published a luxury edition of poems by the Poet Laureate, Alfred, Lord Tennyson, illustrated by a cross-section of artists, including Rossetti, Millais and Holman Hunt. Rossetti's *Palace of Art* was one of five that he executed for the commission. Engraved by the Dalziel brothers, it is an elaboration of spiritual love, taking its tone more from the general excesses of luxury described in the poem than from the chaste verse on which it is based:

> *Or in a clear-wall'd city on the sea*
> *Near gilded organ-pipes, her hair*
> *Wound with white roses, slept St Cecily;*
> *An angel looked at her.*[1]

St Cecilia, the patron saint of music, sinks back from playing her curious organ into the arms of the angel – if that is what he is. The design for her was based on drawings by Lizzie Siddal, who much admired Tennyson's poetry.[2] The scene is enacted in midday heat in a claustrophobic city under siege. In the left foreground a soldier, reminiscent of the style of Ford Madox Brown, munches unconcernedly on an apple, perhaps recalling man's fall in the Garden of Eden. A dove, emerging from the barred space below the figures, may symbolize the unfettered soul or loss of innocence. Tennyson, who hated pictures and took the most attenuated interest in this edition of his poems, is said to have been a good deal puzzled by the illustration.[3] *The Palace of Art* prefigures the intense passion in Rossetti's oils of the 1860s, of which it is most comparable to *Beata Beatrix* (cat. 7). But it also provides a prototype – though disguised in medieval costume – for ecstatic images of sexual love by Edvard Munch and Symbolist painters of the later nineteenth century (see cat. 43).

1. Tennyson, *The Palace of Art*, 1833, verse 25.
2. Marillier, p. 57.
3. Ibid., p. 78.

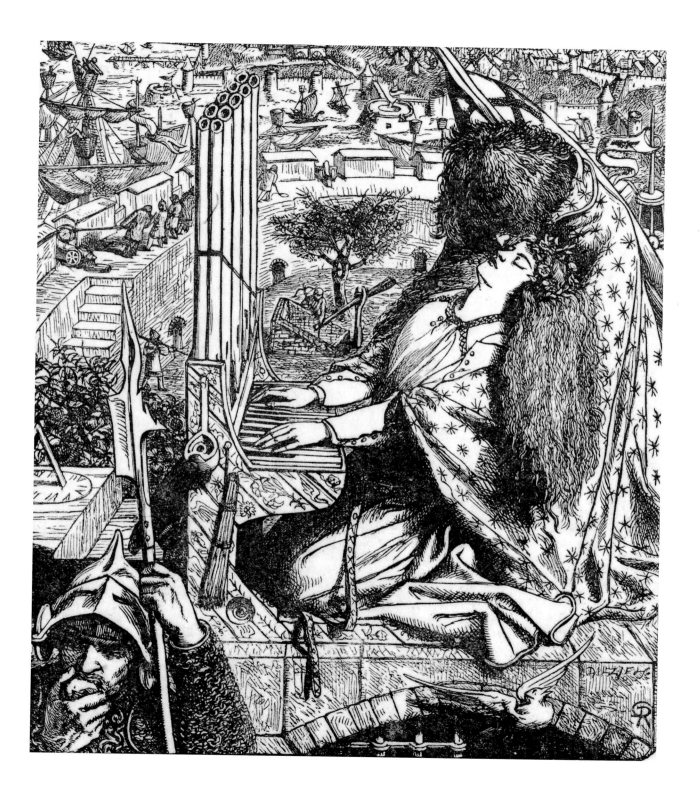

30 *Mary Magdalene at the Door of Simon the Pharisee, 1858*

Pen, Indian ink and grey wash mounted on linen, 50.8 × 45.7 cm
(20³/₄ × 18 in)
Signed in monogram and dated lower right: DGR 1858
The Syndics of the Fitzwilliam Museum, Cambridge [BI]

The theme links Rossetti's intricate, graphic output of the 1850s with the larger works in oil that were to follow. The fallen woman of Victorian dread was often identified with the Biblical figure of Mary Magdalene, but this is an early instance of her transformation into a Christian whose devotion may not be entirely spiritual. Rossetti himself described the scene as enacted between two houses, one of which belongs to Simon, while in the opposite one

> a great banquet is held and feasters are trooping to it . . . Mary Magdalene . . . has been in this procession but has suddenly turned aside at the sight of Christ, and is pressing forward up the steps of Simon's house, and casting the roses from her hair. Her lover and a woman have followed her out of the procession and are laughingly trying to turn her back . . .[1]

The sonnet that he wrote for the work continues:

> *Oh loose me! Seest thou not my Bridegroom's face*
> *That draws me to Him? For his feet my kiss*
> *My hair, my tears he craves today: – and oh!*
> *What words can tell what other day and place*
> *Shall see me clasp these bloodstained feet of His?*
> *He needs me, calls me, loves me: let me go!*

The prominence of the Magdalen's hair is highly significant, for the repentant harlot used it to wipe the feet of Christ. The subject was popular with other artists of the day and Frederick Sandys painted an oil version the following year. Rossetti himself began an oil in 1865 but did not complete it, returning to the theme in 1877 when he produced a half-length version (both Delaware Art Museum, Wilmington). In the present case, the face of Mary Magdalene was taken from Ruth Herbert, while Burne-Jones sat for Christ.

1. Letter from Rossetti to Mrs Clabburn about the unfinished oil replica, July 1865, *Pall Mall Budget*, 22 January 1891, p. 14; quoted by Surtees under no. 109, note 5.

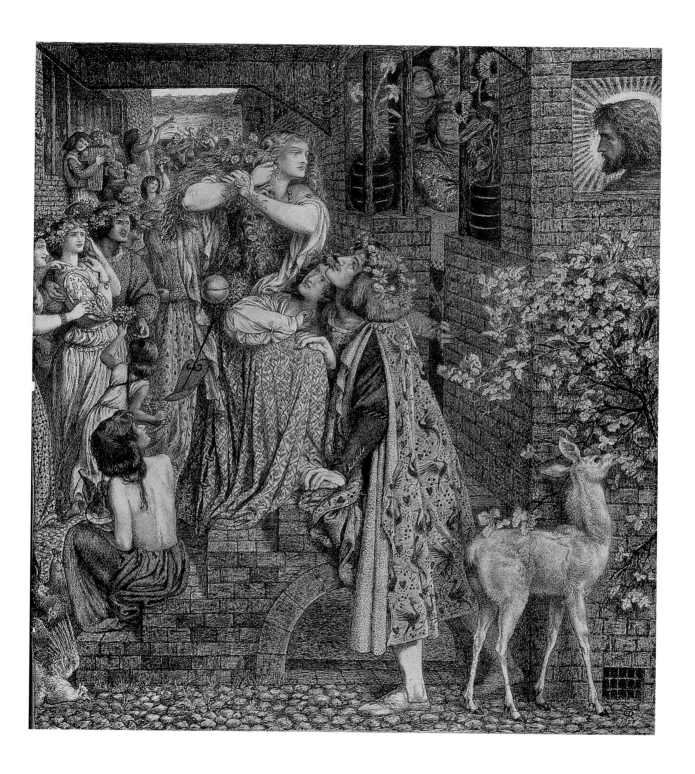

31 *Lucrezia Borgia*, 1860–1, repainted 1868

Watercolour, 41.9 × 24.1 cm (16$^{1}/_{2}$ × 9$^{1}/_{2}$ in)
Signed in monogram lower left: DGR
Tate Britain, London

Lucrezia Borgia, beauty and murderess, washes her hands after preparing a poison draft for her ill-fated husband, Duke Alfonso of Aragon. In the mirror behind her his reflection may be seen, together with that of her father, Pope Alexander VI, who walks him around the room on crutches 'to settle the poison well into his system.' Lucrezia's siren reputation appealed to the nineteenth-century romantic imagination. Rossetti had already produced a watercolour entitled *Borgia* in 1851 and the composer Gaetano Donizetti cemented his international success with an opera on the subject in 1833. Exceptionally, this was a favourite with the deeply unmusical painter, who here incorporates beauty and wickedness in one heroine and uses her luxuriant tresses as a metaphor for a devious, untempered personality. (In this connection Rossetti is likely to have been aware of the lock of Lucrezia's golden hair preserved in the Ambrosiana, Milan.)

The quasi-religious atmosphere, suggested by association with the hand-washing of Pontius Pilate after the condemnation of Christ, is reinforced by an altar-like arrangement beneath the mirror. Rossetti is known to have owned several circular convex mirrors, which he used in other paintings and which were taken up by his followers (see cat. 26). The inclusion of one here as a narrative device may well have been suggested by Jan van Eyck's *Arnolfini Marriage* in the National Gallery. Orange branches in the foreground are an ironic allusion to the sanctity of marriage, while the red poppy and wine on the table portend oblivion.

Lucrezia Borgia was to lead to the break-up of Rossetti's friendship with Frederick Sandys, whom he accused of plagiarizing it for his *Medea* (cat. 20). Exhibited at the Hogarth Club in 1860, it was acquired in 1868 by F. R. Leyland, a regular client of the artist. Rossetti took it back in order to repaint the figure of Lucrezia and at that time probably fitted the gilt reeded frame with applied roundels and squares.[1]

1. Its original appearance is reproduced in Marillier, p. 105.

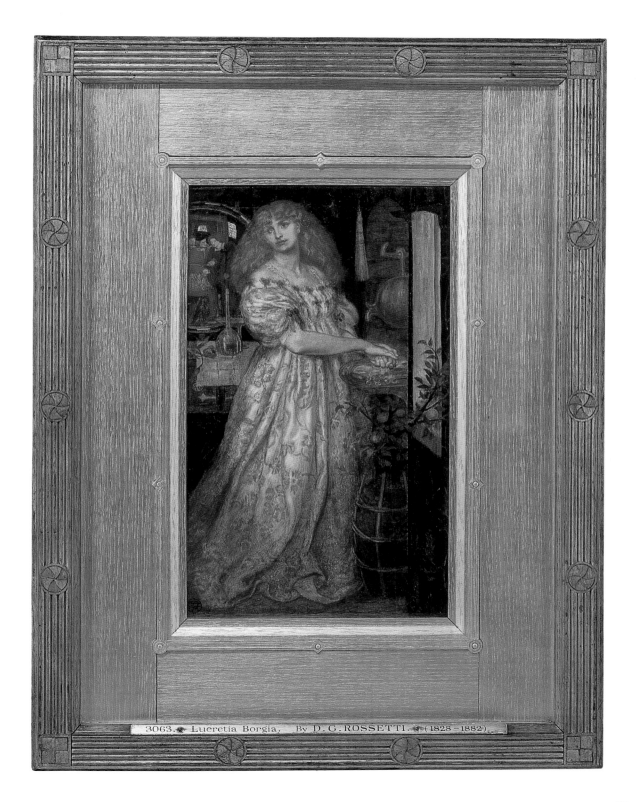

3063. Lucretia Borgia. By D.G. ROSSETTI. (1828–1882).

32 *Morning Music*, 1864

Watercolour and bodycolour, 30.4 × 27.3 cm (12 × 10³/₄ in)
Signed in monogram and dated lower right: DGR 1864
Inscribed lower left: MORNING MUSIC
The Syndics of the Fitzwilliam Museum, Cambridge [BI]

The scene is one of pampered reverie. Rossetti had already treated the theme of a beautiful woman having her hair dressed to the accompaniment of music in *A Christmas Carol* of 1857–8 (Fogg Art Museum, Cambridge, Massachusetts). Here the subject is blatantly sensual and should be compared with *Fazio's Mistress* (fig. 3) and *Lady Lilith* (cat. 6). The musicians recall figures by Giorgione, whose *Concert champêtre* Rossetti admired in the Louvre during his visit in 1864, while the semi-nude girl is reminiscent of Titian's *Young Woman at her Toilet* (Louvre) and Palma Vecchio's *Sybil* (cat. 14). Rossetti must also have known Ruskin's lyrical account of the boyhood of Giorgione, published in 1860 in the last volume of *Modern Painters*, which became an inspiration for Giorgionesque watercolours by Burne-Jones and Simeon Solomon.

The predominance of white, broken by areas of red, green, blue and gold, reflects the ideas on colour harmony advocated by the proponents of 'art for art's sake'. In this respect *Morning Music* is comparable with Whistler's *Symphony in White, No. III* (cat. 19) and Leighton's *Lieder ohne Worte* (cat. 16). The influence of Swinburne on Rossetti is important – both believed that art should gratify the senses, and together they read such 'decadent' books as Baudelaire's *Fleurs du Mal*, Edward Fitzgerald's *Rubáiyát of Omar Khayyám*, the marquis de Sade's *Justine* and Théophile Gautier's *Mademoiselle de Maupin*.[1] The preface to the latter well enshrines their ideas: 'Enjoyment seems to be the end of life, and the only useful thing in the world. God has willed it so. He who created women, perfumes and light . . .'[2]

1. A. Grieve, *The Pre-Raphaelites*, Tate Gallery, London, 1984, p. 298.
2. J. Richardson, trans., *Mademoiselle de Maupin*, 1981, p. 40; cited by Grieve.

33 *Woman combing her Hair*, 1864

Watercolour, 34.3 × 31.1 cm (14^1/$_4$ × 13 in)
Signed in monogram and dated lower left: DGR 1864
Private Collection, UK [BI]

Fanny Cornforth archly displays her ample charms amid an array of luxurious accessories, including a small Oriental blue-and-white bottle. Combing out her copious tresses with one hand, she negligently holds an expensive-looking ivory brush with the other, hinting at the status of kept woman immortalized by Holman Hunt in *The Awakening Conscience* (fig. 7). Reference to the latter is also suggested by the reflected scene behind her. Fanny's neck 'like a tower' is proffered to the viewer, circumscribed by a red tasselled cord disquietingly redolent of blood. In celebrating woman as beautiful temptress the watercolour matches *Fazio's Mistress* (fig. 3), which seems to have been its own original title.[1] Despite the limitations of its medium, the work's breadth and lushness mark a conceptual advance on Rossetti's recent oils – the medievalizing *Fair Rosamund* (cat. 2), the restrained *Girl at a Lattice* (cat. 3) and classical *Helen of Troy* (cat. 4). Fanny Cornforth was certainly Rossetti's mistress by now and their association unleashed the creative energy in him to achieve the major oils of the mid-1860s, such as *The Blue Bower*. By the end of the nineteenth century the present work was known as *Lady in a White Dress* or *Lady in White at her Toilet*. While ignoring the erotic charge of this modern personification of Vanity, such descriptions invoke fascinating links with the experiments of Whistler and Moore and other 'white paintings' of the early Aesthetic Movement.

1. W. Sharp, *Dante Gabriel Rossetti, A Record and Study*, London, 1882, no. 119.

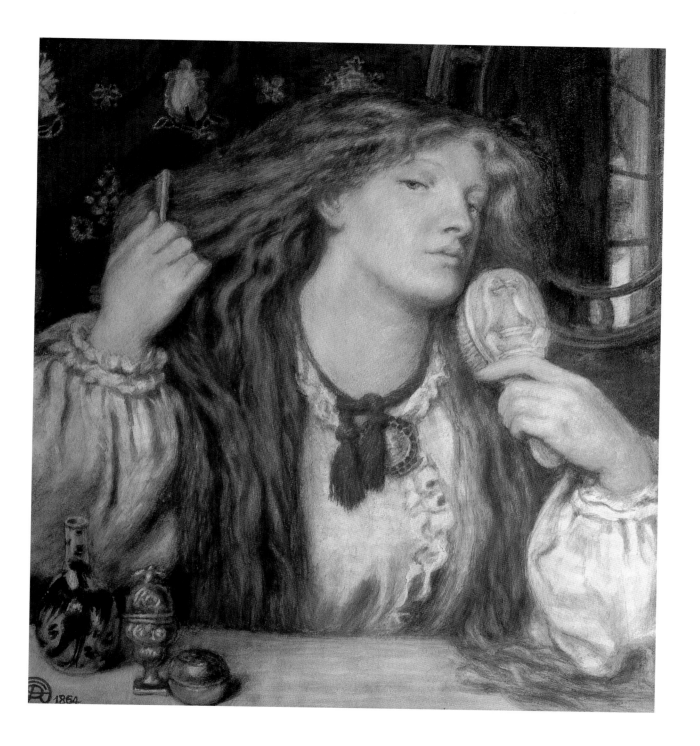

34 *Study for Woman combing her Hair*, 1864

Pencil, 38.1 × 37.3 cm (15 × 14⁵/₈ in)
Signed in monogram and dated lower left: DGR 1864
Birmingham Museums and Art Gallery [CAI]

This study of Fanny Cornforth was made in preparation for the watercolour of the same subject (cat. 33) but concentrates on the figure, shown in preening self-absorption before a mirror. Something of the disparity of Fanny's relationship with Rossetti was recounted by his friend William Allingham. Rossetti carefully explained 'her points' to him 'in that lady's presence and with almost embarrassing minuteness. "Her lips, you see" – following their curve with an indicating finger – "are just the red a woman's lips should always be – not really red at all, but with the bluish pink bloom that you find in a rose petal." – Miss Cornforth the while spreading her ample charms upon a couch and throwing in an occasional giggle or, "Oh, go along, Rissetty".' It is worth recalling that Fanny Cornforth was about thirty when Rossetti made this drawing, though she seems to have lost none of the charms of youth. In this respect William Downey's photograph, taken in 1863, may provide a useful corrective (fig. 1).

1. W. G. Robertson, *Time Was*, London, 1931, pp. 290–1.

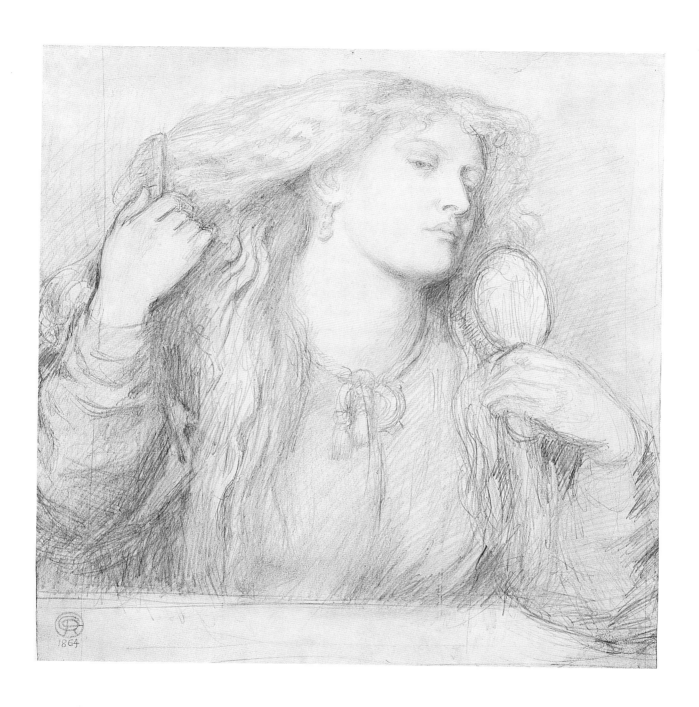

35 *Monna Pomona*, 1864

Watercolour, 46 × 37.8 cm (18$^1/_8$ × 14$^7/_8$ in)
Signed in monogram and dated lower right: DGR 1864
Tate Britain, London

By showing the sitter half-length and close to the picture plane, *Monna Pomona* most nearly approaches Rossetti's contemporary oils. Its setting, composition and colour-range prefigure *The Blue Bower* of the following year, as does the revelation of underwear and flesh allowed by the loosened dress. The model, Ada Vernon, holds an apple in her right hand, hence the title of the work. With her left she toys with her necklace, from which dangles a golden heart crossed with arrows, a love charm that Rossetti would use again in *Regina Cordium* (fig. 11). In a hanging basket suspended before the rich wall fabric is a heady mixture of old white roses, violets and cowslips, while on her lap lie red roses. The scent of these is invoked by the tilt of her head in their direction, thus linking colour harmony with perfume and anticipating the olfactory connoisseurship of J. K. Huysmans's duc des Esseintes by 20 years.[1] The work is in an original 'thumb-mark pattern' frame of Rossetti's own design. It was sold immediately to Constantine Ionides, a major patron of his later years.

1. J. K. Huysmans, *A Rebours*, Paris, 1884, chapter 10.

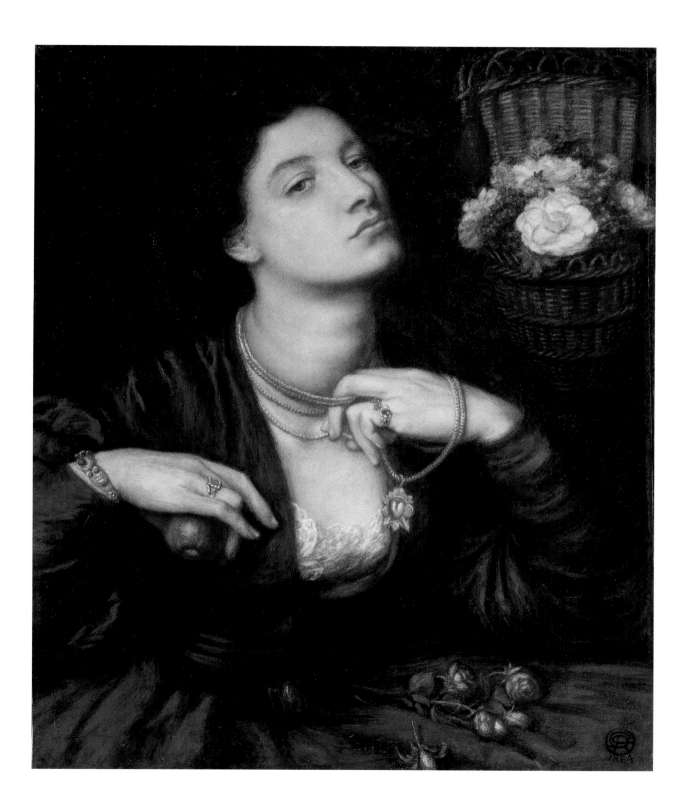

36 *Head of Fanny Cornforth*, 1865

Pencil, 40 × 28.2 cm (15³/₈ × 10¹/₂ in)
Signed in monogram and dated centre left: DGR 1865
Inscribed lower right: The Lumpses
Birmingham Museums and Art Gallery

Evidently a life study, from which the features of Fanny Cornforth were taken for *The Blue Bower*, this is a drawing of serene confidence yet economical means. The inscription, hidden behind the mount, probably refers to Rossetti's pet name for his mistress, 'the Elephant', but seems curiously out of character with the mood of the work and was perhaps added later. A second drawing, similar to this but more detailed, though still omitting any adornments, was bought from Rossetti by George Price Boyce, an admirer of the model, on 22 May 1865.[1] A third drawing, showing her with an upright stringed instrument, is in a private collection (fig. 4).

1. Christie's, London, 14 December 1979, lot 233.

37 Study of a Girl's Head (Fanny Cornforth), 1868

Red chalk, 75 × 59 cm (29$\frac{1}{2}$ × 23$\frac{1}{4}$ in)
Signed in monogram and dated centre right: DGR 1868
Birmingham Museums and Art Gallery [BI]

By 1867 Rossetti's eyesight was causing him trouble and he began to resort to coloured chalks as a medium. This pretty vignette gives his rather stodgy housekeeper, now in her mid-thirties, something of the mysterious allure of a gypsy. Rossetti may have had in mind Frederick Sandys's gypsy mistress, Keomi, whom he had painted in 1865 as the right hand attendant in *The Beloved* (fig. 8).

38 *Woman with a Fan*, 1870

Crayons, 95.9 × 71.1 cm (37³/₄ × 28 in)
Signed in monogram and dated on scroll upper left: DGR 1870
Birmingham Museums and Art Gallery [BI]

By 1869 Rossetti was deeply in love with Jane Burden, Mrs William Morris, and although Fanny Cornforth remained his housekeeper at Cheyne Walk their relationship was more distant. In this large portrait drawing she displays wedding rings and seems almost matronly. The scroll signature reflects Rossetti's interest in Japanese prints, on which such signatures frequently appear (see cat. 39). He later used the device in *Proserpine* (cat. 12) and it appears in Whistler's *Purple and Rose* (cat. 18). Despite this and the exotic Oriental fan – a pun on her name – Fanny Cornforth has now again become the respectable Mrs Timothy Hughes, a status she had assumed in August 1860 in reaction to Rossetti's marriage to Lizzie Siddal.

39 Kitagawa Utamaro (1753–1806)
Two Courtesans, 1795

Signed centre left: Kitagawa Utamaro ga
Colour woodblock, 37.5 × 24.6 cm (14$^{3}/_{4}$ × 9$^{5}/_{8}$ in)
Birmingham Museums and Art Gallery

Following the opening of Japan to the West in 1853, interest in Japanese art and culture grew rapidly in France and Britain, leading to the phenomenon of *japonisme*, eventually to play so large a part in the culture of the Aesthetic Movement. Japanese woodblock prints were among the multifarious objects which became the focus of attention for collectors such as Rossetti and Whistler in the early 1860s. Utamaro was one of the best known and most prolific of the masters of *ukiyo-e* colour prints. He was chiefly renowned for his depictions of women – portraits of famous beauties or courtesans, and elegant genre pieces of female occupations and amusements. *Two Courtesans* is part of a triptych showing the women processing in front of stacked boxes. These are of a type used to steam cakes, but here they serve as decorations for some festive occasion, acting also as a screen that compresses the space in which the two women move. Rossetti used geometrical backdrops to similar effect in several of his paintings of the 1860s, including *The Blue Bower* and *Regina Cordium* (fig. 11). It is uncertain whether he knew this print, but it does have features which he incorporated into his paintings, notably the scroll inscription at the upper right – here recording the names of the courtesans. This he adapted for *Proserpine* and other works (cat. 12). His enthusiasm for Japanese dress was nourished by such prints, leading him, for instance, to adorn the bride in a gorgeous kimono in *The Beloved* (fig. 8). The erotic yet dignified subject would also have appealed to him, as would the exotic decorations of the hair and the restricted yet subtle colour combination of green, beige and orange.

40 Lewis Carroll (Charles Lutwidge Dodgson) (1832–98)
Dante Gabriel Rossetti, 1863

Photograph (albumen print): 14.6 × 12.1 cm (5³/₄ × 4³/₄ in)
National Portrait Gallery, London

Rossetti is shown at the age of 35, seated in the garden of Tudor House, Cheyne Walk. His debonair and rather foreign appearance and his nonchalant pose bespeak an assured yet informal character. It is not difficult to deduce his attractiveness to women, but it is hard to believe that only about eight years separate this likeness from the portrait by G. F. Watts (cat. 24).

He met Lewis Carroll when in Oxford for the decoration of the Union Debating Hall. In October 1863, two years before the publication of *Alice's Adventures in Wonderland*, Carroll asked Rossetti to sit for him as an artistic celebrity and was persuaded to take some photographs of his drawings for showing to prospective clients. Apart from literature, a shared interest was the new medium of photography, which Rossetti used in 1865 to record a series of likenesses of Jane Morris. These were taken in the garden of Tudor House by John Parsons but Rossetti arranged the poses and some of them were used as a basis for paintings. In July 1863 Rossetti, accompanied by Ruskin and William Bell Scott, was photographed in the same spot by William Downey, who also took a group portrait of Swinburne, Rossetti, Fanny Cornforth and William Michael Rossetti in the garden of Tudor House (fig. 15).

41 Frederick Sandys (1829–1904)
Finished Design for 'If', 1866

Pen and ink over traces of pencil, 15.9 × 11.7 cm (6$^1/_4$ × 4$^1/_2$ in)
Birmingham Museums and Art Gallery

Sandys was associated with Rossetti from the late 1850s and had rooms at
Tudor House from 1866 to 1868. During that period he painted a number of
significant works inspired by Rossetti, such as *Medea* (cat. 20). Among his
major achievements were woodcuts and illustrations, including some for
poems by Swinburne and Christina Rossetti. This is his final design for the
wood engraving published in the *Argosy* in March 1866 to accompany the first
publication of Christina Rossetti's poem *If*. It illustrates the lines:

> *If he would come today, today,*
> *today,*
> *Oh what a day today would be!*

Sandys's bulky seated figure with hair streaming in the wind is strongly
reminiscent of Rossetti's depictions of Fanny Cornforth at this period. The
gesture of chewing her hair, also used by Rossetti, reinforces connotations of
dreamy love. In accordance with the original Pre-Raphaelite devotion to
nature, but unlike Rossetti, who was ill at ease with landscape, Sandys based
his background on an actual drawing made near Sheringham, Norfolk, in 1858.

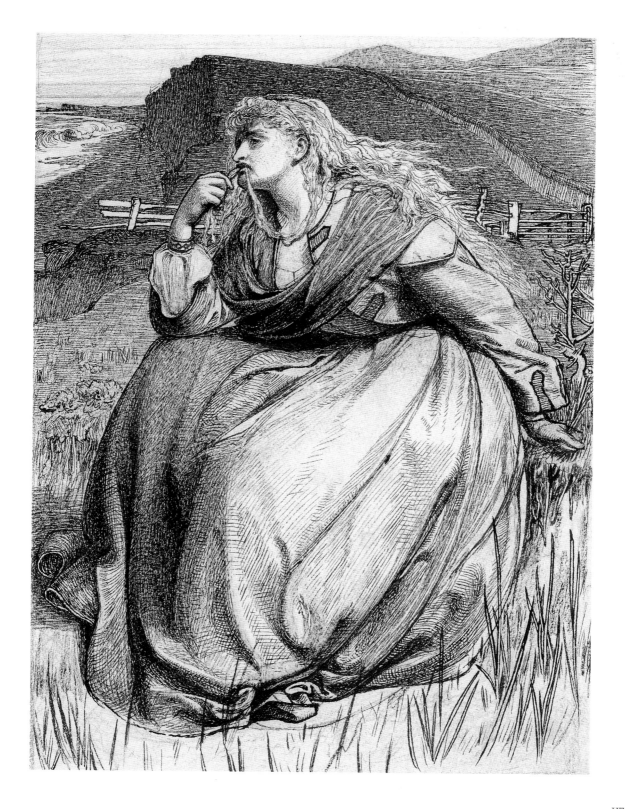

42 Edward Coley Burne-Jones (1833–98)
The Lament, 1866

Watercolour with bodycolour laid down on canvas, 47.5 × 79.5 cm
(18³/₄ × 31¹/₂ in)
Signed in monogram and dated lower left: E.B.J 1866
William Morris Gallery, London

Edward Burne-Jones became, with William Morris, one of the leaders of the second wave of Pre-Raphaelitism, which formed round Rossetti in the late 1850s. He played a major role in the change of direction that overtook British art in the 1860s, stressing idealism and medievalism but also heavily influenced by the Italian Renaissance. He met Rossetti, who was five years his senior, at Oxford in 1856 and by the mid-1860s had become a leading figure of his circle. *The Lament* epitomizes his art at this formative period, having no real subject but seeking primarily to evoke a mood. Like Rossetti's *Blue Bower* and other contemporary works, it depends on music to set the emotional tone. It differs from these single-figure works, however, in its degree of withdrawal and inscrutability, while posing a hint of interaction between two figures. The girl has finished playing the dulcimer, the youth bows in an attitude of grief or submission, and the fallen rose and strewn petals symbolize loss, whether of love or innocence. The setting appears loosely Renaissance, but, as in Leighton's *Lieder ohne Worte* (cat. 16), no specific historical epoch seems intended. Venetian influence accounts for much of the mood and colour scheme of the work, but ancient sculpture is also an important source, especially the Parthenon marbles in the British Museum, which Burne-Jones studied intensively from 1863. In turning to ancient Greece, he was encouraged by Ruskin and G. F. Watts and comes close to Whistler and Moore at the same period, using classical prototypes to introduce qualities of equilibrium and calm into his compositions (cf. cats. 19, 21 and 23). Rossetti, on the other hand, actually discouraged him from studying the antique on the grounds that such study came too early in a man's life and was apt to inhibit his individuality.[1] *The Lament* was exhibited at the Old Water Colour Society in 1869, together with *The Wine of Circe*, which the French art critic Philippe Burty described as 'disturbing and even more powerful than certain parts of the *Fleurs du Mal* by Baudelaire.'[2]

1. G. Burne-Jones, *Memorials of Sir Edward Burne-Jones*, II, 1904, p. 149.
2. *Gazette des Beaux-Arts*, II, 1869, p. 54.

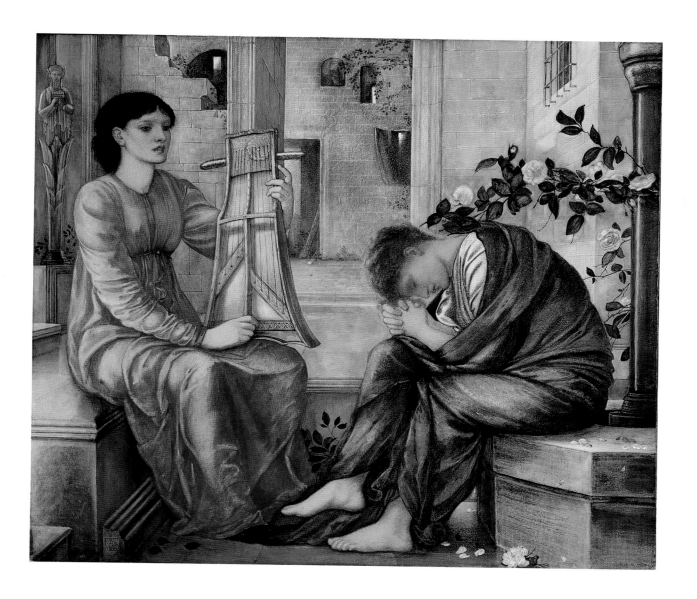

43 Edvard Munch (1863–1944)
Madonna, 1895

Lithograph with touches of gouache, 66.2 × 47.9 cm (26$^1/_8$ × 18$^7/_8$ in)
Signed and inscribed lower right: E. Munch, No 11
The Sterling and Francine Clark Art Institute, Williamstown, Massachusetts

Munch drew his subject matter from the eternal traumas and fears of human existence, overlaid with his own experience and troubled subconscious. In 1885 he left his native Norway for Paris, where the Symbolist movement, with its insistence on clothing ideas in sensuous forms, was about to dominate the arts. There he must have become familiar with Rossetti's work through admirers such as Gustave Moreau and Stéphane Mallarmé. The stunning and highly disturbing *Madonna* forms part of *The Frieze of Life*, a major cycle devoted to love, death and anxiety. He made three oil versions after he had moved to Berlin in 1893, where he came into contact with Franz von Stuck, an admirer of Rossetti. In direct contrast to the pious associations of its title, *Madonna* features a woman who oozes sexual allure, combined with fatal menace. Crowned with a halo of red, the colour of passion, she writhes in ecstasy, her lips and wildly flowing hair echoing the deep sensuousness of Rossettian prototypes such as *Venus Verticordia* (cat. 5). Munch himself observed: 'Your lips, as red as ripening fruit, gently part as if in pain. It is the smile of a corpse.'[1] The link between the supreme moment of physical love and extinction had been treated by Rossetti in *Beata Beatrix* (cat. 7). When Munch first exhibited *Madonna*, which he also called 'Loving Woman', the frame, since lost, was decorated with spermatozoa and embryos. These details he transferred to the lithograph, suggesting ambiguous feelings about the moment of conception, when a new life is created. If the foetus is intended as a personification of himself, further parallels arise with *Beata Beatrix*, where the small figure of Dante represents Rossetti.

1. E. Munch, ms., 'The Tree of Knowledge', MM T 2547, cited in R. Stang, *Edvard Munch: The Man and his Art*, New York, 1979, p. 136.

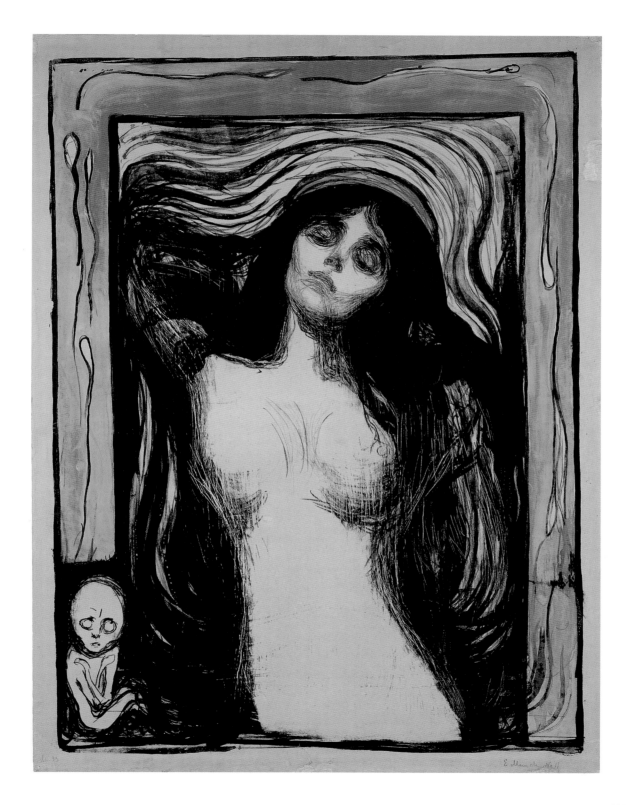

44 European, mid-19th century
Brooch

Silver with applied rosettes, set with three large pastes, 3.5 × 2.98 cm
($1^3/_8$ × $1^1/_8$ in)
Victoria and Albert Museum, London

This heart-shaped brooch features centrally in *The Blue Bower* (cat. 8) as the pendant at Fanny Cornforth's throat, suspended on a necklet chain slipped through its vertical pin. Large and strikingly colourful, it was probably given by Rossetti as a token of love to Jane Burden, Mrs William Morris, in the late 1860s or in the 1870s. Later it passed to May Morris, her younger daughter, who was the model for the angels' heads in *La Ghirlandata* (cat. 11). She was an enthusiastic jeweller and bequeathed the brooch and other jewellery to the Victoria and Albert Museum on her death in October 1938.[1] Described in her will as 'an Indian brooch of big stones mounted in silver', it is clearly a commercial piece. Yet it does not resemble the normal run of costume jewellery manufactured in England and is more like Central European peasant brooches. Despite Rossetti's partnership in the recently founded Morris, Marshall, Faulkner and Company, the brooch is unlikely to have been designed by him or made by 'the Firm'. It was probably bought in a West End antique shop, like other trinkets included in his paintings. In 1873 when the artist was retouching *The Beloved* (fig. 8) he wrote to his assistant, Henry Treffry Dunn: 'I am wanting a big showy looking jewel of the diamond kind . . . I dare say a theatrical jewel such as you could get for a few shillings in Bond Street would do quite well. It would be nice to have it heart shaped, but that might be hard to find.'[2] A jewel similar to the present example fastens the headdress of the bridesmaid on the left of *The Beloved*. An elaborated version of the brooch was made by May Morris in about 1905 (Victoria and Albert Museum) and the shape became the favourite motif of the two best-known jewellers of the Arts and Crafts Movement in Birmingham, Arthur and Georgina Gaskin.

1. S. Bury, 'Rossetti and his Jewellery', *Burlington Magazine*, CXVIII, February 1976, p. 98. Much of the above information is taken from this article.
2. Doughty and Wahl, III, p. 1149.

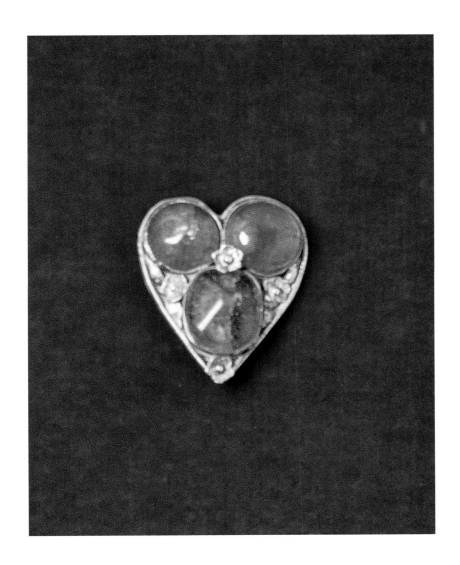

Summary Biography

1828 Born 12 May, London. His father is Gabriele Rossetti, a political refugee from Abruzzi, Italy. His mother is Frances Polidori Rossetti, half English. He has three siblings: Maria Francesca (1827–76), William Michael (1829–1919) and Christina Georgina (1830–94).

1842 Attends Sass's Drawing Academy.

1844 Enters the Royal Academy Antique School as probationer.

1848 Taken on informally as a pupil by Ford Madox Brown for a few weeks only. Later transfers to William Holman Hunt. Founds Pre-Raphaelite Brotherhood with Holman Hunt, John Everett Millais, James Collinson, Frederick George Stephens, William Michael Rossetti and Thomas Woolner.

1849 First public exhibition of paintings by the Pre-Raphaelite Brotherhood at the Royal Academy; Rossetti exhibits *The Girlhood of Mary Virgin* at the Free Exhibition, Hyde Park Corner. Visits France and Belgium with Holman Hunt. Meets Elizabeth Siddal.

1850 Contributes to *The Germ*, a short-lived Pre-Raphaelite journal. Harsh press notices of the Pre-Raphaelite painters at the Royal Academy and of Rossetti's *Ecce Ancilla Domini* at the National Institution, Portland Place. Thereafter Rossetti ceases to exhibit in the major London exhibitions.

1852 Moves to 14 Chatham Place, Blackfriars Bridge.

1854 Begins *Found*, a modern moral subject dealing with prostitution, but fails to complete it. Meets John Ruskin, art critic and patron, who supports him until 1864 and introduces his work to other patrons. Begins drawings for *The Seed of David* for Llandaff Cathedral (1854–60), his only large oil painting of the decade.

1855 Becomes friendly with Robert Browning. Second visit to Paris, to see Exposition Universelle.

1856 Befriends the Oxford undergraduates William Morris and Edward Burne-Jones.

1857 Contributes five illustrations to Moxon's edition of poems by Tennyson. Shows eight works in a private Pre-Raphaelite exhibition, Russell Place, Fitzroy Square. Organizes the mural decorations of the Debating Hall in the Oxford Union Society. Meets Algernon Charles Swinburne. Falls in love with seventeen-year-old Jane Burden.

1858 Founds Hogarth Club (1858–61), an exhibiting and social club, with Ford Madox Brown, Burne-Jones and others.

1859	Paints *Bocca Baciata*, the first of his oils of idealized beauties. Jane Burden marries William Morris.
1860	23 May, Rossetti marries Elizabeth Siddal. Third visit to Paris, on honeymoon, where he admires Veronese.
1861	Publishes *The Early Italian Poets*. Foundation of 'the Firm' (Morris, Marshall, Faulkner and Company) with Morris, Burne-Jones, Ford Madox Brown and others. His wife bears a still-born child.
1862	11 February, death of Elizabeth Siddal from an overdose of laudanum. Rossetti moves to Tudor House, 16 Cheyne Walk, Chelsea, where he remains for the rest of his life. International Exhibition held in London.
1863	Fanny Cornforth becomes housekeeper at Tudor House. Rossetti visits Belgium with his brother, William Michael.
1864	Fourth visit to Paris. Shown round Courbet's studio by Henri Fantin-Latour. Visits Manet's studio.
1865	Paints *The Blue Bower*. Starts using Alexa Wilding and Jane Morris regularly as models.
1866	Beginning of eye trouble and illness.
1869	Has the poems he had placed in his wife's coffin exhumed by Charles Augustus Howell, who later becomes his agent.
1870	Completes *Beata Beatrix*, in memory of Elizabeth Siddal. Publishes *Poems*.
1871	Robert Buchanan publishes 'The Fleshly School of Poetry' in *The Contemporary Review*, attacking Rossetti and his associates. Takes lease of Kelmscott Manor, Oxfordshire, together with William Morris (1871–74). Paints Dante's *Dream at the Time of the Death of Beatrice* (Walker Art Gallery, Liverpool), his largest oil.
1872	Suffers a nervous breakdown and attempts suicide.
1881	Suffers a stroke. New edition of *Poems* published, together with *Ballads and Sonnets*.
1882	9 April, dies at Birchington-on-Sea.
1883	Memorial exhibitions held at the Royal Academy and Burlington Fine Arts Club at last familiarize the public with his work.

Select Bibliography

The Age of Rossetti, Burne-Jones and Watts: Symbolism in Britain 1860–1910,
 exh. cat., Tate Gallery, London, 1997.

Allen, Virginia M., '"One strangling golden hair": Dante Gabriel Rossetti's
 Lady Lilith', *Art Bulletin*, LXVI, June 1984, pp. 285–94.

Barringer, Tim, *Reading the Pre-Raphaelites*, London, 1998.

Baum, Paull F. (ed.), *D. G. Rossetti's Letters to Fanny Cornforth*, Baltimore, 1940.

Buchanan, Robert (signed Thomas Maitland), 'The Fleshly School of Poetry',
 Contemporary Review, XVIII, October 1871, pp. 334–50.

Bury, Shirley, 'Rossetti and his Jewellery', *Burlington Magazine*, CXVIII,
 February 1976, pp. 93–102.

Caine, Thomas Hall, *Recollections of Dante Gabriel Rossetti*, London, 1882.

Casteras, Susan P., and Faxon, Alicia Craig (eds), *Pre-Raphaelite Art in its
 European Context*, Cranbury, NJ, 1995.

Dante Gabriel Rossetti, Painter and Poet, exh. cat., Royal Academy of Arts,
 London, 1973.

Doughty, Oswald, *A Victorian Romantic: Dante Gabriel Rossetti*, 2nd edn,
 London, 1963.

Doughty, Oswald, and Wahl, John Robert (eds), *Letters of Dante Gabriel
 Rossetti*, 4 vols, Oxford, 1965–7.

Dunn, Henry Treffry, *Recollections of Dante Gabriel Rossetti and his Circle*,
 ed. Rosalie Mander, Westerham, 1984.

Edward Burne-Jones, Victorian Artist-Dreamer, exh. cat., Birmingham
 Museums and Art Gallery, 1998.

Faxon, Alicia Craig, *Dante Gabriel Rossetti*, new edition, London, 1994.

Frederic Leighton, exh. cat., Royal Academy of Arts, London, 1996.

Frederick Sandys 1829–1904, exh. cat., Brighton Museum and Art Gallery,
 1974.

Grieve, A., 'The applied art of Rossetti: i. His picture frames', *Burlington
 Magazine*, CXV, January 1973, pp. 16–24.

Grylls, Rosalie Glynn, *Portrait of Rossetti*, London, 1964.

James McNeill Whistler, exh. cat., Tate Gallery, London, 1994.

Japan and Britain: An Aesthetic Dialogue 1850–1930, exh. cat., Barbican Art
 Gallery, London, 1991.

MacCarthy, Fiona, *William Morris: A Man for our Time*, London, 1995.

Macleod, Dianne Sachko, *Dante Gabriel Rossetti: A Critical Analysis of the Late
 Works, 1859–1882*, PhD thesis, University of California, 1981; Ann Arbor,
 UMI, 1999.

Macleod, Dianne Sachko, 'Dante Gabriel Rossetti and Titian', *Apollo*, CXXI,
 January 1985, pp. 36–9.

Marillier, H. C., *Dante Gabriel Rossetti: An Illustrated Memorial of his Art and Life*, London, 1899.

Marsh, Jan, *Pre-Raphaelite Sisterhood*, London, 1985.

Marsh, Jan, *Dante Gabriel Rossetti, Painter and Poet*, London, 1999.

Notes on the Royal Academy Exhibition, 1868. Part I by William Michael Rossetti; Part II by Algernon C. Swinburne, London, 1868.

Pedrick, Gale, *Life with Rossetti*, London, 1964.

Pollock, Griselda, *Vision and Difference: Femininity, Feminism and Histories of Art*, London, 1998.

The Pre-Raphaelites, exh. cat., Tate Gallery, London, 1984.

Prettejohn, Elizabeth, *Rossetti and his Circle*, London, 1997.

Rose, Andrea, *Pre-Raphaelite Portraits*, Oxford, 1981.

Rossetti, William Michael, *Dante Gabriel Rossetti as Designer and Writer*, London, 1889.

Rossetti, William Michael (ed.), *The Poetical Works of Dante Gabriel Rossetti*, London, 1891.

Rossetti, William Michael (ed.), *Rossetti Papers 1862–1870*, London, 1903.

Sharp, William, *Dante Gabriel Rossetti: A Record and a Study*, London, 1882.

Smith, Alison, *The Victorian Nude*, Manchester, 1996.

Smith, Sarah Phelps, *Dante Gabriel Rossetti's Flower Imagery and the Meaning of his Painting*, PhD thesis, University of Pittsburgh, 1978; Ann Arbor, UMI, 1981.

Stephens, F. G., *Dante Gabriel Rossetti*, Portfolio Monograph, London, 1894.

Surtees, Virginia, *The Paintings and Drawings of Dante Gabriel Rossetti (1828–1882): A Catalogue Raisonné*, 2 vols, Oxford, 1971.

Surtees, Virginia (ed.), *The Diaries of George Price Boyce*, Norwich, 1980.

Waugh, Evelyn, *Rossetti: His Life and Works*, London, 1928.

For a fuller bibliography, see W. E. Fredeman (ed.), *Pre-Raphaelitism: A Bibliocritical Study*, Cambridge, Massachusetts, 1965.

Photographic Credits